the complete guide to
digital photography

Printed in the UK by MPG Books Ltd, Bodmin

Distributed in the US by Publishers Group West

Published by: Sanctuary Publishing Limited, 45-53 Sinclair Road, London
W14 0NS, United Kingdom

www.sanctuarypublishing.com

Cover image courtesy of Photonica

ISBN: 1-86074-498-2

the complete guide to
digital photography

MARK TOWSE

Sanctuary

contents

introduction

Photography has always been a popular hobby: how many people do you know who don't own a camera? Exactly! However, all that fiddling about with buying films, taking bad pictures and paying to even get to look at what you've shot has obvious drawbacks. Thanks to the digital revolution, photography enthusiasts now have access to a myriad of digital cameras, editing software, printers and the like, but it isn't always easy knowing exactly what is going to be right for you. Even when you've got all the kit you need to take the first steps into your new digital pastime, it can involve a horrendous amount of extra study to find out what does what and how and why and... Fortunately, that's why this book and I are here!

Everything you need to enable you to take better pictures and a complete guide of how to add effects, remove unwanted items, correct colour, print at photographic resolution, publish a digital web album and even change your physical appearance are now all at your fingertips. By the time you finish this book, you can safely claim to have the same knowledge as a digital photography pro and for the rest of your life you will be able to take pictures you can be proud of!

I have structured this book to make sure that you can get the most out of each chapter. Chapter 1 deals with taking the best quality digital photographs in the first place, how to improve your technique, how your camera actually takes digital images and how it affects the way you should take your pictures. Chapter 2 covers the practical side of what to do when you actually have these images in your computer and covers a lot of the fun stuff you might want to know, but don't want to take a three-year degree course to learn. The appendices at the back of the book will give you all the information you need should you want to take your photography knowledge to the next level. I have kept technical information and jargon to a necessary minimum to allow you to concentrate on the important stuff: taking better photographs.

Right then, let's get our hands dirty!

on the CD

We are lucky enough to have a complete, save-disabled demo version of the world-leading, industry-standard image-editing software, Adobe Photoshop on the CD-ROM, which will enable you to take part in all the practical tutorials covered later in the book.

PC users

To install, insert the CD-ROM, click 'run' from the Start menu, and type in 'D:', which is the name of your CD drive. (If you have an extra hard drive or extra DVD writer, it may be 'E:'.) In the window which pops up, double-click in the 'PC_software' section and double-click on the 'setup.exe' file. Easy as that! You can use similar navigation techniques for finding all of the images used within the tutorial later in the book. By double-clicking on an image file, it will be opened up within Photoshop.

Mac users

To install, insert the CD-ROM and double-click the folder that appears on your desktop. Navigate to the 'Mac_software' folder, double-click on the file there and the automatic installer will do the rest. You can navigate to the images used in the tutorial section of the book in a similar way, and by double-clicking on an image file, it will be opened up within Photoshop.

Enjoy!

the art of digital photography

I n this chapter we will look at all the aspects of digital photography: from how your camera actually creates digital images to becoming a better photographer with your digital kit.

an introduction to digital photography

Traditionally, photographers come in two distinct categories: the home user (either a family flicker or a hardened, darkroom hobbyist) and the professional. Today, the boundaries between amateurs and professionals have become very blurred. No longer does somebody serious about their photography have to go to the expense of setting up a darkroom, getting light-headed from chemicals and taking hours to get that perfect exposure. Now, anybody owning a computer, a printer and a digital camera has the capacity to take high quality images with minimal fuss and have them printed out better than your local developing facility.

The problem is that even when you have your digital camera, there are many subtle differences about the camera which can seriously affect the quality of your images. Further than just differences with your digital camera, the knowledge base that most people have about what to do with images once they are on the computer is limited at best. Just a small amount of applied knowledge can lead to the most atrocious camerawork becoming digital mastery that friends, family and even potential clients are bound to be impressed by.

In the past, you had one shot at getting your photographs perfect and the most important part of photography was catching that 'perfect' moment. Now, thanks to the digital age, you can have as many shots as you like and – more importantly – you can fiddle, manipulate and effectively stage-manage your digital photos to become anything you can see in your mind's eye.

Digital photography is as exciting an advance in the field of photography as you are ever likely to experience. By the end of this book, you will have all the skills needed to keep that excitement brimming for ever!

how do digital cameras work?

Waves of light bounce around us everywhere. When they strike your retina, your optical nerve sends a message which the brain converts into a constantly updated picture. Digital cameras work in exactly the same way. An aperture covering the camera lens rapidly opens and closes, letting in a miniscule amount of light: just enough to record the light passing through the lens at the moment of opening.

This is then bounced on a CCD (Charged Coupled Device), a sensor that converts light waves to electrons and sends them through a chip that acts as an analogue to digital converts. This converter then maps the structure of the light that has been passed to it and converts the relative light values of each *pixel* (short for picture cell) to a binary digital value, consisting of zeros and ones.

This information is then converted to an image format which will later be read by your computer. Most digital cameras use a variation of the JPEG (Joint Photographic Experts Group) image format, which can be read by both Macs and PCs running any major operating system.

Traditionally, chemical-coated film was used to take pictures that created a negative that could then be printed to produce the photos we have all grown up with. The concept is the same. Because digital cameras use this 'light map' to produce images, there are maximum sizes of images that can be created.

The size of an image (the number of pixels along an image's width and length) is known as the resolution. Some high-end cameras have resolutions in excess of 4,800 x 3,600, but most digital cameras offer resolutions of 640 x 480, 1,280 x 960 and 2,400 x 800. When you actually do the maths, an image with a resolution of 1,280 x 960, for example, gives 1,228,800: over a million pixels of recorded-light information. When a camera is able to take pictures at a resolution of 1,280 x 960, it will generally claim to be a 1.2 mega-pixel camera.

The CCD has been the mainstay of digital imaging for some time and is used extensively in digital video cameras. A rival type of imaging sensor, the CMOS image sensor, is not generally used as the chip is susceptible to 'noise', which would interfere with the quality of the picture .

Well, you'll be pleased to know that is the most 'techy' this book intends to get; from here on in it's all plain sailing.

choosing your digital camera

Digital cameras have exploded on to the market relatively recently and despite the different looks, styles and bravado-laden claims, ultimately they all function with the same technology and produce only minor variations in the quality of the images. Given this, as with every major purchase you make, it isn't always easy to see the wood for the trees. There is a lot of unnecessary jargon and clutter, which should largely be avoided. These are some very simple points that you should consider when about to purchase a new digital camera.

ensure the camera has a suitable resolution

Resolution is the size of the image measured in horizontal and vertical pixels. Most cameras are able to take pictures at a number of different resolutions, but to make sure the camera will be right for you, you will need to think about how you will be using the images you plan to take with the camera.

If you are going to take shots and e-mail them to friends and family then you can get by with a resolution of 640 x 480. Any less that this and images will be too small to be of much use; so, make sure that if this is the maximum resolution of your camera, you don't intend to do much with it! Forking out for the next level up, 1,280 x 960, allows you to enter the real photography ballpark. This is the entry 1.2 mega pixel-level resolution; after this, any increase is a bonus. From this level you will be able to print images that are photograph sized and with the same quality as 'normal' photographs, if printed on the correct paper. The higher the pixel resolution, the larger the size of the pictures you can print at photograph quality. Any camera with a higher than 3.1 mega pixel-level resolution is only to be considered for hardened professionals who need to be able to photograph complex pictures with absolute accuracy.

This chart explains the maximum resolution needed to print pictures at a certain size with photograph quality.

Passport size	0.3	640 x 480 pixels
4 x 5 inches	0.4	768 x 512 pixels
5 x 7 inches	0.8	1,152 x 768 pixels
8 x 10 inches	1.6	1,536 x 1,024 pixels

One final word of warning: make sure you know the camera's 'actual' resolution, not its interpolated resolutions. Manufacturers of many of the less expensive cameras boast about their product's resolution, but they have only arrived at this figure thanks to software that has filled in a lot of the gaps that the camera's image sensor couldn't. This is the digital-camera equivalent of small print.

memory issues

Cameras use film; digital cameras use storage media that vary depending on the manufacturer. When you buy your camera, you will get a removable storage device which has a Mb (Megabyte) number: 4Mb or 8Mb is what you generally get bundled in with a camera, but you can get sizes up to 64 and 128Mb. It is always handy to get an extra memory stick, smart card, compact flash card or whatever standard is adopted by your camera's manufacturer, as even though digital cameras have the ability to delete unwanted snaps on the fly, small cards fill up too quickly. On my first digital camera, I could only save five shots at the top resolution on the card that was supplied! Investing in a 64Mb card will let you save up to 700 640 x 480 images, which should be more than enough for even the most itchy-fingered snapper.

ensuring you have a suitable lens

Most digital cameras don't have removable lenses and many of the cheaper models (anything under £200 [$350]) don't have many of the extras and add-ons that the higher-priced models have available. With this in mind, you need to make sure you know what can be achieved with your lens. Think about what you aim to take the most pictures of and check that the camera lens is able to do this. You should be able to test your camera before purchase.

know your zoom requirements

As with digital video cameras, optical and digital zooms are commonplace, but whereas you may get in excess of 80X digital zoom, the quality of anything above 8X would be so poor it would be unusable. If you want to be able to use a powerful zoom, you should pay attention to the optical zoom capabilities on offer.

is it a power-hungry muncher?

One of the only drawbacks of digital cameras is that they drain batteries like the clappers. New levels of battery technology, Nimh (Nickel Metal Hydride) and Lion (Lithium Ion) batteries, now enable your digital camera to view pictures on its display screen for over four hours, but the moment you start taking pictures and using the flash, this can all disappear in as little as an hour, depending how intensively you snap. Some manufacturers have their own bespoke battery variations which can cost a small fortune, so make sure you can use normal rechargeable batteries as described above, otherwise you'll be paying out for the rest of your life with no guarantee that the batteries will still be available in years to come.

Intangibles such as whether you like the shape of the camera, whether you read a good review about it, or even whether you like its colour can make your decision for you, but remember these things may not benefit your actual needs.

what does your computer need?

In order to make large-scale storage a possibility, digital cameras need to be able to store the images you take in a digital format and save them to as tiny a format as possible. Given this, your computer, be it Mac or PC, only needs a very low technical specification for you to be able to create a fully functioning photographic workshop.

basic computer hardware

A basic PC system with the following technical specifications will be 100 per cent suitable for all your digital imaging needs:

- Intel Pentium-class processor (400MHz or above)

- Microsoft Windows 98 or above

- 64Mb of RAM (extra RAM is always advisable and is very cheap)

- 280Mb of available hard-disk space, enough to accommodate essential imagery software

- 800 x 600 colour monitor with a 16-bit SVGA colour or video card

- a USB interface

Most PC computers sold since 1998 are of vastly higher specification than the above statistics.

mac

PowerPC® processor (G3, G4 or G4 dual)

- Mac OS software version 9.1, 9.2, or Mac OS X version 10.1.3

- 64Mb of RAM (extra RAM is always advisable and is very cheap)

- 320Mb of available hard-disk space, for essential imagery software

- 800 x 600 colour monitor with 16-bit colour or greater video card

- a USB interface

more about USB

USB (Universal Serial Bus) is a technology that enables one standard port in your computer to take any type of peripheral, be it a camera, scanner, sound system, mouse – you name it. Most new PCs and all Macs come with at least two USB sockets, although because so many computer extras use these sockets, it is worthwhile investing £10 ($15) in a USB extension which will have two, four or six extra slots. USB is the standard way digital cameras transfer images on to your computer.

printers

Gone are the days of the dot-matrix Epsons that took half an hour to print a page of iffy-looking text. Even printers from as low as £49 ($70) are more than capable of printing pictures that look as though they had been taken with traditional film. Before selecting your printer, you should bear in mind the following considerations. Printers can be attached to your computer via either USB or a serial interface; most come with both connectors.

scanners

A scanner is not a specific requirement for your digital-photography workshop, but very useful, especially when you enter the world of image post-production in the second half of this book. Like printers, scanner technology has come on in leaps and bounds over the past few years, to the extent that any scanner over £69 ($99) will be able to scan at a resolution that the human eye cannot differentiate between – meaning a scan will look as good as the real thing. Scanners can be attached to your computer via either USB or a serial interface; most come with both connectors.

graphics tablets

Graphics tablets provide an indispensable way of quickly navigating your computer and are particularly useful in image-editing software. Graphics tablets have come a long way in recent years and now a £30 ($50) tablet is responsive, easy to use and has different pressure settings for complete control. They can be a little tricky to get to grips with at first, but time learning to master a graphics tablet completely removes a lot of wear and tear on your mouse-controlling arm: a worthy investment.

what other equipment would be useful?

The great thing about digital photography is that your camera, computer and printer make a complete photography package but, as with most things in life, a few other bits and pieces can make all the difference to the quality of your photographs. For digital cameras, the amount of add-ons and extra peripherals is much more limited than for traditional photography as the industry is still young. Due to the many warring digital-photography factions, it isn't likely that a huge amount will become available in the near future.

Bags and cases are the most important 'extras', as your camera will generally have come with a soft case that is unlikely to be fully sealed when closed. Given this, it is important that you have a good-quality case for any shooting that could take place in inclement weather or for when you are in a more exciting location, such as up a mountain or on a hike. Metal cases offer the best protection and are, as you may expect, the most expensive. Always ensure that whatever extra casing solution you purchase has several different-sized partitions - and also make sure your camera actually fits inside! Most cases have been built for traditional camera usage and thus slightly more 'normal' camera shapes and sized partitions will be built in. With digital cameras coming in more varied and design-focused shapes, it is important to make sure you get a snug fit. Some larger manufacturers of digital cameras, like Fuji and Sony, have ranges of accessories for specific cameras, but check for your individual camera first. Hand and shoulder straps are also essential for your carrying requirements.

tripods and monopods

Tripods may seem a far cry from something that you would want to use on a regular basis, but the difference some stable support for your camera can make to the quality of your images is astounding. Also, they are absolutely essential for any sort of panoramic images. No matter how steady you think you are, you're never that steady! Monopods are identical in function to tripods, but have only one leg. This makes a mobile monopod very useful for travel situations where you may not want to lug around its heavy three-legged sibling: your two legs and the one from your monopod give you a tripod! There are obvious slight degradations in balance and stability which you will have to weigh up dependent on your needs. A small table-top tripod is a good idea for home usage where you intend to get a lot of family-related shots.

Most digital cameras now have a universal screw-in slot that will accommodate your tripod or monopod, but do check on the bottom of your camera before you make your purchase.

extra storage cards

Traditional photographers will, obviously, carry masses of extra film around for that perfect shooting moment. Just because you are digital and can shoot hundreds of pictures per storage card, that doesn't mean you aren't going to run out of space; you may want to shoot at a higher resolution than you had previously expected. This alone is reason to make sure you always have at least one more storage card at hand.

lens-cleaning kit

A lens-cleaning kit is probably the single most under-used accessory for any non-pro photographer, traditional or digital. They are inexpensive and allow you to clean your camera lens safely without touching and potentially damaging it. You would be surprised how much difference a regular bi-monthly clean of an active camera lens can make to the sharpness of your images.

battery chargers and extra batteries

Yes, all digital cameras require batteries, but that bog-standard charger that takes eight hours to recharge removes all the fun from digital photography. There are a number of great one-hour rapid chargers which work with all high-powered digital camera batteries – and a fast charger makes all the difference.

Extra batteries are always essential and owning at least three pairs is useful: whenever you want to take a picture, you can. In order to prolong their lifespan, it is important to remember to let batteries in your camera completely run down before recharging them.

**Extra storage media are your equivalent of extra rolls of film.
Always make sure you have at least 16Mb spare.**

extra lenses

Despite the fact that many digital cameras simply don't have the capacity for lens changes, some manufacturers, like Nikon and Fuji, do have lens extensions that take into account your individual camera's lens setup and can be adjusted accordingly. Generally, lens extensions are only available for many higher-priced (£300+ [$500+]) digital cameras. Different lenses give professionals a greater degree of zoom, a different aperture or field of vision. Generally, only a semi-pro digital photographer would need to consider these requirements.

digital-camera features in depth

Digital cameras mean digital features. There are a great deal of features that may be present on your camera, all designed to make sure you get the best possible images. However, these features and settings can be a little daunting and often go untouched throughout the lifetime of the camera. Learning all the features your camera has is essential to being able to get the best photographs you can. Equally, using the wrong feature at the wrong time can ruin an otherwise exceptional photo, so make sure you fully understand all these features.

framing

As with traditional cameras, your digital camera will contain a frame that ensures you can place the focal point of an image in a 'safe' area of the photograph. By 'safe' I mean in an area that will not be cropped when the image is actually stored in its digital format.

Depending on your camera model, you may have a specific framing guideline function. This function will enable you to cycle between different framing set-ups. Framing in such a way is used for more 'standard' shots such as pets and people or landscapes.

scene-framing guideline

This is often split into either four quarters or a grid of nine boxes, which will allow you to position the scene equally. By selecting this framing option you are also telling the camera that it shouldn't focus on any specific region.

group-shot-framing guidelines

This generally resembles the traditional static framing guideline you get on non-digital cameras. You should use group shots whenever there are two or

The one downside of a digital camera is that it needs batteries to function. Digital cameras can be very power intensive, especially if you are using the flash a lot or shooting at higher resolutions. Always make sure you have a few spares.

more grouped focal points to a picture, be they animals, people, cars or whatever. The camera will know that the elements in the frame (which should be as distinct as possible) should have extra focus.

portrait-framing guidelines

This type of framing will have up to five progressively larger boxes in which you should frame your subject's face as tightly as possible. This gives your picture the optimum possible perspective for your distance from the target.

None of the lines you see on your camera's display screen will be recorded on the final photograph.

autofocus function

Almost all digital cameras have an autofocus function. This is essential as there are relatively limited means for digital cameras to modify their focus, unlike traditional cameras. Autofocus has hidden depths as well. Often, you can point the camera at the object you want to be the main focal point of your shot, set the autofocus by pressing the relevant key or pressing the picture button down halfway, then moving the camera to house the rest of the shot. The camera will then focus specifically on the item or object that

has the autofocus set on it and provide that region with added clarity. Autofocus will generally give you reasonable-quality pictures under most circumstances, but if you only wanted reasonable-quality photos, you wouldn't be reading this book!

portrait function

This is another general function that should appear on all digital cameras. This feature gives added focus and attention to detail for lighter tones usually associated with skin. These features have generally only been considered from a Caucasian perspective and those with darker skin may find the portrait function doesn't give a huge advantage over a standard autofocus shot. Portrait images will give an overall softer image, which is great for evening-out facial features.

Portrait applies specifically to the type of photo (ie that of people) and not to alignment terms that specify paper in a printer, for example, so the shape of the photograph will be the standard wider-than-height shot. It is often a good idea to turn your camera through 90 degrees when shooting portraits to remove an excess of unused imagery around the subject.

Your camera will allow you to frame automatically, giving you no manual focus hassles.

landscape function

Again, this function is designed for taking landscapes and does not change the dimensions of the actual photograph. It is specifically designed for taking daytime landscape shots and, unlike the portrait setting, will give a sharp, clear image over the entire picture, without picking out a particular element for any enhanced focus. Some cameras will automatically disable the flash facility for this kind of picture; it is always a good idea to make sure this feature is turned off when landscape mode is on. You should use your camera's white balance to ensure optimum clarity.

night scene

Night scene functionality is not a standard feature on all digital cameras, but on mid-range and above it should be an ordinary feature. This mode is able to enhance images where there is not a lot of natural light available. For the camera to be able to take in all available natural light, the camera shutter will operate more slowly, with cameras generally allowing up to three seconds for the picture to be finished and stored. This means that if there are any fast-moving objects within the shot (cars, trains, etc) you will get a blurred ghost image when the photo is finished. With this in mind, attempt to shoot night scenes using this mode only if the subject of the picture can remain static throughout.

You should be able to choose to 'force flash' with night scene turned on. This is useful when you have a large night scene which contains people within a range of about 3m (10'). By using the force flash you can remove unwanted red-eye which often plagues badly lit shots.

white balance

White balance represents one of the most under-used features on any digital camera. It is used because – wait for it – white isn't, in fact, white! When we look at a piece of white paper which has a shadow covering it, we still know that the paper is white. Machines don't know this. All they see is a darker colour than white, made up of red, green and blue hues which are then stored as an image: the human eye adapts; the machine does not. If you are in a white room, you are likely to have as many as three or four distinctly different shades of white, along with all the shadows of the room.

To ensure that the camera sees white as white and not a myriad of different shades requires a white-balance adjustment to the kind of light that dominates the scene.

image 1 image 2

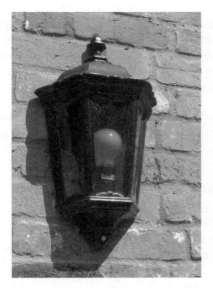 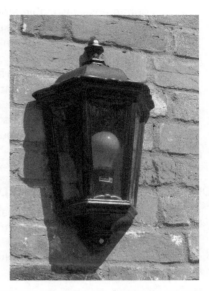

This Georgian-style iron lamp has white balance set for outdoor light in image 1 and set for indoor fluorescent strip lighting in image 2. The difference in tonal values and the way the picture holds together is a stark reminder of how important it is to remember to change your white balance whenever you enter new lighting conditions.

All cameras with a white-balance function can make automatic adjustments, but often it is a bit hit or miss as to the specific effect that will be achieved. Your camera will also have specific settings for shooting outdoors, inside, under 'daylight' fluorescent lamps, under 'warm' tonal fluorescent lamps, under harsh 'kitchen' fluorescent lamps and for incandescent light. This gamut of different settings may seem small, but actually encompasses almost all daytime or inside lighting conditions. Changing this white balance every time you have a different lighting condition is essential, and the results in your pictures will be instantaneous.

Digital cameras will generally ignore any white-balance modifications when the camera's flash is used.

brightness and exposure adjustment

Digital cameras are very sensitive to brightness and to get the best possible shots it is important to be able to modify the camera's sensitivity to brightness depending on the situation. If you are shooting a skiing picture up a mountain on a sunny day, there is likely to be too much light around for a picture to

contain any reasonable amount of detail. With this in mind, you would want to tell the camera that there is a lot of brightness, so the camera can compensate and give you the maximum amount of detail within the scene. Specific levels of sensitivity which can be changed vary between cameras, but generally you should expect to be able to alter levels from -1.5 to +1.5EV (exposure variation) with increments dependent on the manufacturer.

The following are some useful situations where changing the EV would be beneficial. The bracketed numbers are tried and tested levels that can be used as a good rule of thumb.

positive white-balance compensation

- Photographing white paper with black text on it (+1.2 to 1.5EV)
- Backlit portraits (+0.4 to 1.5EV)
- Mountains/Skiing shots (+0.8 to 1.2EV)
- Shots of bright or lightly overcast sky (+0.9EV)

negative white-balance compensation

- Spotlit subjects (-0.6EV)
- Photographing magazine text or light characters on a darker background (-0.6EV)
- Matt (non-reflective) shots taken with many objects of similar colours, such as forests (-0.6 to -0.2EV)

Knowing how to change your camera's brightness and getting a feel for general EV changes in different circumstances and settings will increase the quality of your pictures immediately.

autobracketing

What happens when you aren't sure about which exposure settings to use? Higher-end cameras mean you don't have to go through a lengthy process of shooting, changing settings, reshooting and comparing.

With autobracketing, three consecutive pictures are taken, each with a different EV setting. Specifics will depend on your camera, but you will generally have the standard settings you are using and then the option of +/-1EV, +/-2/3EV or +/-1/3EV.

You will then be able to compare the three pictures instantly on your display screen and save the best to your storage medium.

continuous shooting

This is essentially autobracketing without the differences in exposure. You get three pictures with a minimal length of time between shots. This can be very useful for taking group pictures where getting everyone smiling at exactly the right moment is tricky. With three to pick from you have a better chance of getting the right shot.

flash

Most digital cameras come with a flash, and generally people know what a flash is for, but using it correctly is a different story altogether. Flash is for use in dark or insufficiently lit scenes. Where most people come unstuck is by having an incorrect distance between the subject and the camera. As a good rule of thumb 0.2m to 4m (0.7' to 13') is about right, but the power of your flash will depend on your camera.

Many higher-end cameras have the option to adjust the brightness of the flash. For pictures taken where the focus is closer to the camera you should decrease the power of the flash; further away, increase. It will take a bit of guess-work the first few times you experiment with different flash-brightness levels, as all built-in flashes have different intensities. Making sure you have a feel for the correct flash strength will improve your pictures quickly.

Depending on your camera, you may have several flash modes. These range from red-eye reduction and auto to forced flash and shot synchronisation. We will look at flash modes in depth later in the book.

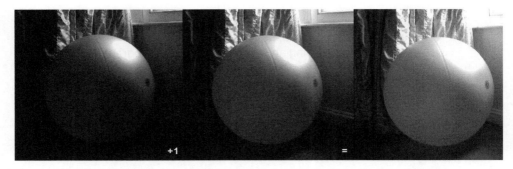

This indoor shot displays how autobracketing can give you the chance to pick the right image from the three on display. The photos here also display exactly how much difference your photographs can change by modifying your camera's sensitivity to brightness.

sharpness

The landscape and portrait modes in your camera are all well and good but every different scene has different requirements (you'll learn a lot more about these requirements later on!). Many cameras will allow you to increase or decrease the level of sharpness within a picture by plus or minus one unit: +1 will increase sharpness, 0 is good for sharpness on outlines and softness for non-edge detail and -1 will give a softer overall shot, with softer edges.

Isn't that just the same as for portrait and landscape shots? Well, yes, but when you are taking pictures manually and need to combine various different settings that aren't compatible with the individual landscape and portrait modes, recognition of how to use these settings becomes important.

Remember, all cameras are different, but this selection of features should help you understand what is available and provide a quick insight into what each feature can actually do to help you get better pictures!

what makes a good photograph and photographer?

The aim of Chapter 1 of this book is to help you understand the way your camera works and how you can utilise this knowledge in the way you decide to compose your pictures. All pictures are subjective; no matter how duff a photography expert thinks your family album is technically, it will always contain beautiful pictures to you.

You don't have to be a pro to be drawn to an out-of-the-blue picture – dynamic, well lit, interesting and thought provoking – but why shouldn't all your pictures be that impressive?

If you can take photographs which communicate with everyone on an emotional level, rather than just biased, interested parties, then you have gone a long way down the road to being an innovative, skilful photographer.

Your pictures will always be subjective, but professional photographers are those who understand what they are doing when they take a picture and why they want to capture it in a certain way. When you have finished with this book, hopefully you will no longer be a click-and-hope amateur, but a rounded digital expert.

When you know you are communicating to the world through photography and when you know what to consider (and why) before you take a picture, you are a good photographer!

lenses and focusing

The lens maketh the camera, so the saying goes. A lens is a convex glass plate through which light shines and is focused into the area occupied by the CCD sensor. The light, as it passes through the lens, is flipped upside down when it is recorded. Hardware inside the on-board computer re-flips the image the right way when you view it on your display screen (if your camera has one). The quality of the lens you get in your digital camera is directly proportionate to the price and it determines the quality of the image you are able to take. Cheap digital cameras that seem to have the same specifications in terms of resolution and features will often have a much cheaper lens, which isn't fatal but can mean that in time the lens becomes quickly tarnished, more suspect to light fluctuations when taking pictures in bright scenes and can have an effect on the quality of colour. Sony, Fuji and Nikon are all respected for the quality of their lenses. Most importantly, the quality of your lens will be a big determining factor in how well your camera focuses on a subject in a picture.

The point at which light rays from the lens converge on the CCD sensor to give a clear and sharp image is the definition of focus. It is easy to see if your subject is in focus. If when you look through your viewfinder your subject appears blurred, it is out of focus. This means the lens has to have its position altered so that the light from the subject converges to form a sharp image. In days of traditional photography, many cameras employed a focus ring, which was a very useful tool. Despite its usefulness, it has largely been rendered obsolete in this new digital age and has been replaced with manual-focus buttons. They don't feel the same, but they can be very accurate, as every time you touch the button your options screen will tell you exactly how much the focus has changed, meaning you can build up knowledge of different focal requirements as your photography improves. Digital cameras, like conventional cameras, tend to assume that the focus is always to be in the centre of a picture. Check if your digital camera has a 'variable focus' option, which should allow you to point the centre of the camera at your subject (even if the subject is eventually to be in the top-left of your picture), set the focus to remain on the centred subject and then move the camera to frame the actual shot you want. Digital trickery then maintains the focus of the previously centred item which is now in the top-left of your picture. The on-board computer does this by two methods, depending on your make and model: either by examining light and colour values of the focused object and tracking them, or by calculating the change in the coordinates of the centre of the frame at the point the focus is selected and then applying the focus to the change in camera position.

Focusing correctly isn't just a case of pressing buttons to change focus; knowing why pressing the buttons makes for a better focus is a key lesson in digital

photography. When you change focus, you are actually changing the distance between the lens and the CCD, and thus affecting how the light will hit the sensor. When the lens is at its closest setting to the CCD, distant subjects such as people in the distance or landscape shots are going to be sharply in focus. As you modify focus settings and move the lens further away from the CCD, distant objects dissolve and closer subjects will focus. This is because light nearer the lens can converge on to the centre of the CCD and give good focus.

Knowing this allows you to focus on a scene behind a strong foreground subject and slowly bring the shot to perfect focus on the foreground subject, while blurring the background. This kind of shot always looks good.

different types of lenses

One of the problems with some lower-priced digital cameras is that although the lens is suitable for general usage - landscapes, portraits, group photos, etc - there is little scope for any of the more advanced photography styles available when you can change a camera's lens. Only very high-end cameras have the ability to completely swap lenses for different photographic situations. Some mid- to high- range cameras have various add-on lenses that combine with the fixed lens of the digital camera to offer added functionality. You should check with your manufacturer for the type of extension lenses available for your camera. It may, indeed, be a contributing factor when you initially purchase a digital camera. This is a rundown of various lens types, what they do and why they are useful.

telephoto lenses

Telephoto lenses increase magnification by a fixed amount. Using this in conjunction with your camera's ordinary optical and digital zoom functions will allow you to shoot faraway objects with great ease. There are some extra technical pluses to using such lenses, namely that the telephoto lens will slightly compress any image taken with it. This can be good for shooting portraits, with the picture's depth of field being less than without the lens so dominant parts of a subject's face - eyes, lips and nose - can be accentuated.

wide-angle lenses

Wide-angle lenses, as their name suggests, spread the field of view that your camera can see and thus increase the width of pictures you can take. Although this may sound like an ideal lens to have available for shooting landscapes, there are some inherent difficulties for digital-camera users. Even if we increase the angle of a lens, it still has a maximum resolution that the CCD

sensor can convert to a digital image: just because the lens is sending wider light waves to the CCD, the CCD doesn't expand to accommodate this. This means that if you're using a wide-angle extension, even when using your camera's maximum resolution, you may find the image distorts to an unusable amount. Equally though, there are various benefits, including being able to shoot a subject closer to the camera while keeping a background completely in focus, which can enhance many photographs and give you a whole new gamut of creative abilities.

zoom lenses

These lenses extend the zoom ability of your camera, acting in conjunction with your camera's inherent zoom options to allow great close-ups. These lenses differ from telephoto lenses in that they are variable and thus are often found more useful by photographers. There are masses of zoom lenses available for the traditional camera user, but probably a limited selection if you are using an extension lens for your digital camera. New peripherals for cameras are always coming out in a manufacturer's range, so check regularly if you do need such a lens.

macro lenses

Some digital cameras have a macro option built in, allowing you to take extreme, close-up photographs in focus instead of being limited to a standard digital camera's 2-metre minimum focus range. If you don't have a macro option, you will need to get a macro lens (sometimes called a bellows device), which will allow you the same functionality. It is worth noting that some zoom lenses have a macro lens built in, so if you require both you should try to get one that satisfies both needs, to save money.

fish-eye lenses

These lenses are more fun than those used in general photography because they give uncorrected wide angles and hence interesting distortion. Fish-eye lenses simulate looking through a fish eye. The lens is more convex than a standard lens and light refracts at a more extreme angle. It is unlikely you would ever need to use this kind of lens and, as far as I am aware, no fish-eye extensions exist for any digital cameras costing under £1,000 ($1,500).

lens aperture, shutter speed and exposure trickery

Lens aperture and shutter speed go together to determine how much light reaches your image sensor to create an image, so understanding their

relationship is vital and will be important when you begin experimenting with different exposure levels and other tricks of the light.

The lens aperture is what lets light through to your camera's lens and CCD. When you take a photo the aperture opens and lets in a certain amount of light. If your camera is set for a sunny-day setting, the aperture will not open far to avoid over-flooding the picture with light. Indoors or in cloudy weather, the aperture will open wider so more light can pass through the lens, hit your CCD and give the right image. So, in summary, the aperture is the 'gap' that light has to travel through to your lens and CCD. Like a sink filled with water, the bigger the size of the plughole, the more water rushes through.

Shutter speed, on the other hand, is the length of time light is allowed to spill through the aperture, through the lens and into your sensor. If the aperture is the size of the plughole, the shutter is the plug.

Combining the size of the aperture and the shutter speed gives your exposure and, by combining different shutter speeds and different aperture sizes, you can modify the amount of light that is registered in your image, creating a number of cool light effects.

Exposure is the term used to define the volume of light which actually reaches the CCD sensor in your digital camera to create a photograph when the aperture opens and closes. A photograph is also known as an 'exposure', as it has been created from a sensor's 'exposure' to light.

What, then, defines a correct exposure? Getting the right amount of light into your lens to create the image that you want. You may have noticed that the last phrase was particularly open-ended and it needed to be, as there is no specific 'correct' exposure. As long as you get the picture that you intended, everything else is subject to the viewer of your photograph.

When you begin photography, you can be satisfied that you have achieved the correct exposure when you have roughly proportionate highlights, mid-tones and shadows within your image: that detail is correctly proportionate to what you were seeing when the picture was taken.

The fun begins when you start experimenting with different shutter speeds, thus increasing the amount of exposure the light sensor is subject to. Suddenly you aren't taking good photos, but you are experimenting with different tonal values of light. Unless you have a very high-end digital camera, you are likely to have only a very few settings for modifying your shutter speed. With a little luck, you will have your standard setting and then one or two faster and slower

shutter speeds. By increasing the shutter speed, you give light less time to hit the CCD sensor and form an image. You may think that this would simply give pictures with less detail or pictures that would be generally darker as all the tonal information hasn't been registered. There is truth in both of these points, but by using light sneakily you can create vivid photographs which would otherwise be out of reach.

For example, in a scene which has a lot of highlights reflecting at the camera, set the shutter speed to the fastest possible setting so minimum light gets the chance to register. Because of the sensitivity of the CCD, you will get an image that is made up almost purely of the highlights, with any detail on the shadowed areas being removed, thus creating a massively contrasting and very exciting photograph.

Shooting bright day scenes with a camera's night-shot function turned on will massively over-expose an image, giving an image flooded with light with a blanched feel; only a few of the darkest parts of the image will stand out to offer any level of detail. The image may be over-exposed technically, but if you get a good picture from the technique and you are satisfied with it, then you have got correct exposure.

zoom: optical versus digital

Your digital camera, unless it is very low-end, will have some form of zoom. Zoom is used, as the name suggests, to 'zoom' into an object, making it larger so you don't have to be so close to your subject. There are two types of zoom: optical and digital. When buying your digital camera you will have probably thought, 'Oh, the optical zoom looks a bit weedy, but wow – look at what the digital zoom can do!' This is a common reaction to seeing an optical zoom of between 2X and 3X (meaning you can zoom in to twice or three times the size of what you can initially see in your viewfinder) and then seeing a digital zoom that can go higher than 80X. The digital zoom, however, is a big misnomer as it is simply an interpolated zoom, which takes the present optical zoom you have, uses software to guess what is in the image and then artificially blows it up. Realistically, you are lucky to get any serviceable imagery from anything above an 8X digital zoom-factor, and even this will have a serious degradation of quality.

Optical zoom, on the other hand, changes the focal length of your camera's lens. The light rays are magnified in the same way a magnifying glass works, resulting in the image projected on to the CCD sensor looking closer. Optical zoom is so-called as the magnification comes from the lens (optics being another name for lenses). Optical zoom is 'real'; digital zoom is interpolated.

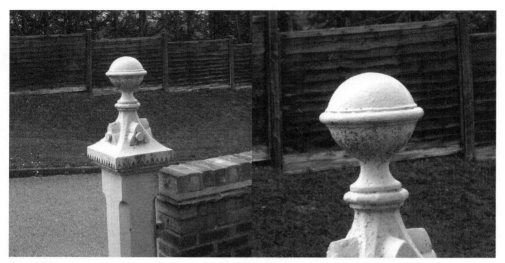

The two comparative images here show the maximum possible optical zooms. Interpolating with your digital zoom functions will simply begin degrading quality; avoid this if at all possible.

Optical zoom is the only type that will genuinely give a real magnified view and thus the only zoom that will really enhance your photography. If you can help it, use digital zoom as little as possible.

lighting

Lighting makes a picture: it defines mood, accentuates colour, displays edges and detail, and even entire genres of photography have been defined purely by their use of lighting. It doesn't take a genius to work out that lighting and learning how to make the most of light is one of the most important elements of photography. There are two places to consider lighting: outdoors and indoors.

lighting outdoors

Daylight is the obvious mainstay for outdoor photography, but street lighting, neon lights and even the *aurora borealis* are all outdoor lights which can be used in photography to subtly alter the tone of the picture.

Many people go for years without knowing a thing about lighting within a scene, yet this is one of the overriding factors that define whether a photograph will turn out good or bad. It is very easy to alter general brightness and darkness values within a piece of image-editing software *post factum*, but getting the correct balance in the initial photograph saves a lot of graft later on.

The first point to lighting is to look at where your main subject is being lit from. The old adage that you should always shoot with the sun behind you is rubbish; indeed, when light is square on to your subject, colours become flattened and contrast is lost, thus affecting the picture's overall detail level.

When shooting people in natural light you should be careful that no strong light source, natural or otherwise, shines square into their face. Your subject will suffer from involuntary unnatural facial expressions and your picture (unless that was your stylistic goal!) will be ruined. Side lighting or lights off to either diagonal work particularly well as enough shadow is created to accentuate facial contours and give the subject enough depth and perspective to hold well in a two-dimensional format. Back lighting (with the sun behind your subject and the camera facing the light source) can work on occasion, but you should be sure to alter your brightness-sensitivity controls. Using autobracketing for such shots is also useful as you can never be sure exactly how your digital camera will record such light extremes.

You can't alter the natural daylight you have to work with, so having a flexible subject is always useful where possible.

For non-subject-orientated photographs such as landscapes, the type of light you are working with can present some interesting styles. Overcast days will generally leave a landscape looking flat and lifeless, but if you are creating a gritty photography of a run-down coal mine, this will add to the impact of the overall picture, whereas a bright, sunny day would give a completely different impression. Timing is important as natural light varies according to the time of day. On a day out, people tend to be where they want to be and start taking any related pictures at around lunchtime, with the sun very high in the sky. This gives a good overall ambient light, but can create flat images. Shooting before 11:30am and after 2pm at least gives some extra tonal shadows for many static features in a scene.

Hazy, thin cirrus clouds can, on a bright day, be very useful in removing any unwanted flare and excessively bright directional light, while maintaining vivid colour saturation within a scene. Gently overcast conditions still offer your subject enough shadow to give depth to a picture.

With natural light, a little common sense will pay dividends, but experimentation with different light conditions and combining them with different brightness settings on your camera can often further enhance images.

You may not have absolute control over natural light, but by thinking pragmatically you can often use it favourably.

lighting indoors

Indoor lighting is a much more complex subject than outdoor lighting. With outdoor lighting, you are pretty much stuck with what you get; indoor lighting requires an understanding of different light types and how they affect your subject. The ability to add extra light or modify existing light to fall on your subject differently can enhance your indoor photography no end.

Natural light indoors, such as light coming in through windows, is one of the harder light types to use because of its limited penetration into the indoor environment. Right next to a window, light coming in is the most vivid and can create powerful shadows behind a subject, leading to very moody, shadow-filled shots. This kind of light tends to detract from detail. Where these shadows exist, pictures tend to be dark and have a lot more contrast than in standard artificially lit photos. The high levels of contrast have the benefit of making people looking at your pictures believe that you are very artistic. It's a cheap way to get kudos, but any photos which look more interesting than ones you would previously have taken are always a good starting point for improving your overall photography skills. When a subject is by a window, shooting from the side gives these nice artistic contrasting shots, whereas taking a photo from directly in front of the subject gives the same feel as an outdoors backlit shot and can give interesting silhouettes. Using two sheets of white cardboard angled towards the face of a subject, reflecting the backlit light, can give enough light to avoid needing artificial light indoors. By using your digital camera's autobracketing function to take the shots with different brightness settings, you can often get the most out of limited available light and get very impressively lit images.

Artificial lighting is a different game completely. Lamps and light fixtures are generally fixed and there can be any number in a room, usually overhead. Depending on the type of light fitting, you may have soft shadows that accentuate a subject's features or harsh ones that can detract from the overall feel of a picture. Having access to directional lamps and placing them so the fall-off from the lamp (the less harsh light at the edge of a lamp's influence) can be positioned to remove harsher shadows created by fluorescent lights, while retaining the fluorescent lights, produces excellent colour balance. Kitchen fluorescent lights are very good for accentuating colours, whereas the softer tones created by lights with lampshades in living rooms can often distort colour balance across an entire image.

Ensuring you have set your white balance for the correct kind of light is important here as the colour distortion created by any lighting which doesn't throw clear white light can only be lessened, and not completely removed.

Shooting in a living room with a number of soft lights may distort colour, but the presence of several lights can be very good for softening facial features and removing the harsh shadows that fluorescent lighting often adds to a shot.

Any light which falls directly on to a subject from the front can give a flatter feel to the photograph, so it is a good tip to position a lamp out of shot to the side of your subject to add some artificial shadows and create extra contours that give added interest and detail to what could otherwise be a bland 'home' scene.

Experimenting with the different feel created by different placement of subjects in relation to artificial light is great for enhancing your photographic skills. Placing artificial lighting behind a subject, for example, shooting a subject head-on with only one side of the subject lit by artificial light, shooting a subject with the camera facing upwards towards an overhead light are all methods that can enhance your creativity and are great ways to get interesting shots that show you how the artificial light you have available is working in conjunction with your camera.

Most pro photographers try to avoid any artificial lighting created by home fittings, purely for the colour distortion and excess of uncontrollable shadows that are created. I prefer natural light too, and use it indoors wherever possible.

Make the most of all available lighting conditions. The weirder ones, such as this sunny halo being diffused by cloud surrounding a mountain, gives an incredibly powerful effect. The stranger the lighting, the more interesting the result!

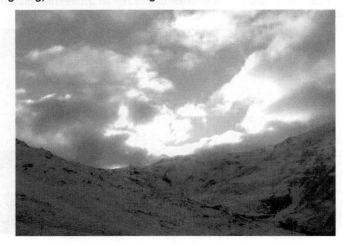

close-up photography

Many traditional cameras allow the interchange of lenses with the body so different objects can be shot more accurately. Mid- and lower-end digital cameras don't have this option, so you will not always have an easy ride when attempting to take a picture of a close object. For a basic digital camera, your effective range for close-up pictures is about 2m (6'). Any less than this and your image will not focus properly. For all my talk about good photography being subjective, it is true to say that it is very hard to get a good picture of a small subject if you don't have a macro function.

Digital-camera users who haven't got access to a digital-macro shooting function shouldn't despair as there are extension lenses, known as bellows units, which can fit around a camera's lens and enable a standard lens to focus on small objects.

When undertaking close-up photography, the light coming into your lens from a smaller than normal subject has to be distributed over the same standard CCD area. This means that there is generally less light available for your shot, so your image will be less vivid than it normally would. With this in mind, you will need to manually increase your exposure or reduce the shutter speed slightly to make up for this deficiency.

Depth of field (the amount of perceived perspective in a picture) is radically reduced when focusing on something close to the camera, so be aware that any type of close-up shot you want to take will have little or no perspective.

Natural light and the reflections it creates can make an interesting picture from even the most mundane household scene.

shooting in bad weather

Don't get miserable when it's raining. Think about the different tones and lighting conditions you now have at your disposal for making interesting, moody photos! Okay, I'm a sun man myself, but taking pictures in bad weather can definitely yield some interesting results. Equally, there are ways of ensuring your digital camera survives a battle with the elements. If you and your camera do battle against the elements together, you can find a host of wonderful scenes that you would never be able to capture under more clement conditions.

Digital cameras are electronic devices and as such respond badly to water. So you do need to take steps to prevent the two coming into contact. In light rain and scattered showers, you may be able to get by with an umbrella, as long as there are no strong winds which could blow water underneath the umbrella's protective shade. There are a number of cases available that have a soft plastic outline, and a good-quality neutral glass lens that can be used with any size or shape of digital camera will enable you to brave even the worst storms. Rain on the exterior of the case can be a positive or negative stylistic addition to your pictures; that's for you to decide!

This dragonfly was about 400mm from the camera without the macro option turned on. This is the best possible shot achievable using only standard focus.

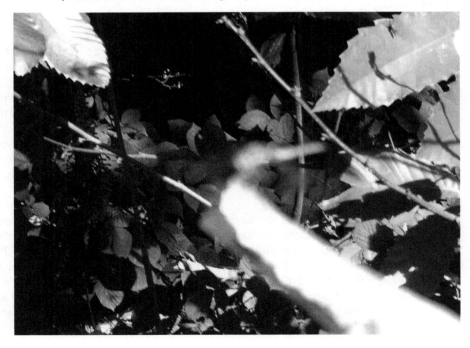

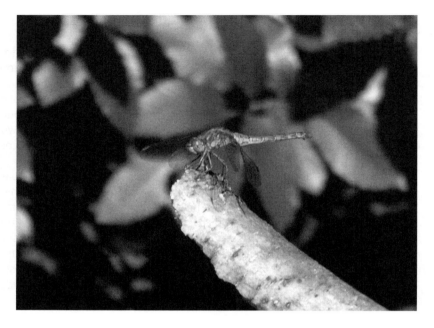

Macro option kicks in and the dragonfly is now detailed and in focus, even close up. Your macro option will still only go so far though, so experiment with your individual camera's settings.

Rain is the weather that people normally consider to be 'bad'. It's certainly the most common condition and also one that can instantly provide a host of photo-enhancing situations. Directly after rain, all colours within a landscape are muted and outlines, even in the starkest landscape, will appear softer. Whenever you get a chance to take a landscape after rain, do so. Relatively few pictures are ever taken under such conditions, as most people won't go out while there is still the chance of another shower and everywhere is sodden. The effects can be outstanding, however, with many extra natural reflections caused by waterlogged features within a scene, strange highlights and turbulent skies.

Urban post-rain shots can be equally rewarding. Wet city streets can give a photo a murky, suppressed feel, and when the sun breaks through and intense reflections shoot up from the ground, the effect can be truly electric. Urban post-rain shots in the evening or at night can offer another world of inspiration as house lights, traffic headlamps, neon signs and the like all reflect in the fresh rain creating seedy atmospheres to vibrant and exciting cityscapes. Often, with such intense imagery, you will find it very easy to be inspired and

catch interesting photographs without having to put too much headwork into setting up a shot. This can be excellent for your early forays into different photographic styles.

Rainbows never seem to look quite as vivid in the print as they do when you take a picture. Remember me harping on about brightness and modifying your EV values? Well, if you bear in mind that the rainbow itself is a light source – light waves refracting in a hazy water cloud and reflected on to your eyes – and use your autobracketing option set on the standard -1 / 0 / +1 setting, you will find that depending on your light conditions, you will get one image with more vivid and saturated colours.

High wind is actually a great weather condition for photographers, especially on clear and sunny days. Everything you shoot is influenced by heavy winds: if you're shooting landscapes, trees, flowers and grass fight to stay stable and great feelings of movement and action can be captured with minimal preparation of your shot. People's coats or hair streak wildly with the flow of the wind and make for great dynamic imagery. The next time it's blowing a gale and not raining, get out and snap. You'll be glad you did.

Mist and fog can make very good atmospheric photographs, but it isn't always easy to focus or get good lighting conditions and using your flash in fog simply doesn't work (if the fog is reasonably thick you'll get a flat glob of light in the middle of your picture and no sense of depth or perspective).

All in all, most people's photographs are taken on clement, mild, clear or sunny days. This doesn't need to be the case. Obviously, people tend to go out on days when the weather is nice, but when a few tricky conditions throw themselves at you, don't think, 'Oh, no!'; think, 'Oh, yes!'

shooting landscapes

This is an area of photography that everyone will have a crack at at some point. Thanks to the handiwork of Mother Nature, it is also one of the easiest branches of photography. A nicely lit, interesting landscape can take your imagination to far-off places, tell a story in a picture or set the scene for an entire collection of pictures. Digital cameras make landscapes doubly easy by having a specific landscape setting. If yours does not, change the image sharpness in your camera's options to its highest level. This increases detail within a picture by more clearly defining any present edges within a scene. Landscapes generally have more detail than, say, a picture of your cat (lovely though I'm sure he or she is) so it is important to capture as much of that detail as possible.

As with all other photography though, it is very easy to assume too much and make a great landscape look dull through lack of imaginative foresight. You may be looking down on one of the most impressive glaciers from the top of the most exquisite of mountains, but if the essence of what you see is not captured within the small rectangle of your viewfinder, then nobody else will be able to share your sense of awe. You must ensure that what is captured in your picture actually stands alone as an interesting individual image, not simply as something that is individually meaningless. If your landscape looks interesting, ask yourself, 'What is it about the gobsmackingly beautiful scene that actually makes me feel that way?' When you can isolate the best elements of a landscape you are seeing, you can better compose your photograph.

Because landscapes are static, the main tools you have to work with to make a landscape shot interesting are scale and perspective. There is absolutely nothing wrong with a few landscape shots taken flat on and lacking depth, but if all your pictures share the same scale and perspective, then all they do is record the way something looks. They do nothing to convey any natural beauty which, by altering your vantage point, changing the way you are aligned to the light source or the amount of visible sky, can make or break your shot.

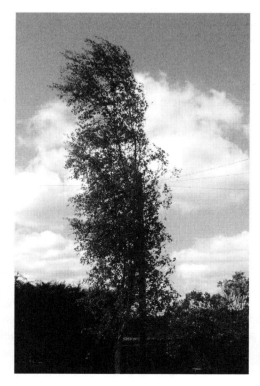

Photographing the effect of wind on a blustery day is a great way of adding a feel of motion to your pictures.

Adding more sky can lead to a feeling of vastness, even when the landscape consists of relatively uninspiring features. Removing sky and focusing on the landmass does the opposite: it encloses and makes a scene look busier.

The time you take your landscape can be very important as between 11:30am and 1pm the sun is generally directly overhead, depending on your geographical location. This can flatten out colours and detail within a landscape, even if at the time it looks very interesting to you. Given this, try to shoot before or after these times when shadows will increase enough to give an extra visual dimension to your landscapes.

Shooting very early or very late (just before sunset) can give a very haunting look to pictures, with long drawn-out shadows dominating even fairly bland expanses of hills. If you are out and about and find a nice landscape, shoot it and return under different lighting conditions later in the day so you have a different and potentially better perspective to your initial shot.

When shooting a landscape, you may often be in a situation where there is not ideal light. With this in mind, using your night-shot function would be a benefit. A tripod is very useful for this kind of shot as otherwise you will have to put up with some camera shake within a scene, which can be difficult (but not impossible) to remove in your image-editing suite.

Finally, remember that a landscape isn't just a beach where you went on holiday or some other conventional place of beauty. An industrial estate, a desolate urban skyline, a landfill site, a power station: these types of places can provide excellent photographic material that you simply may not have considered before. Taking a brilliant photograph from an unexpected source can be one of the art's most satisfying elements.

shooting family

Despite my general loathing of the way family pictures have become the most bland and unimaginative types of picture, that doesn't mean they aren't the most popular and – to the people who take the shots – the most important. With this in mind, these are specific tips about how you can get the most out of a myriad of 'normal' everyday photographic situations. All the tips are fully transferable and when you understand the reason for certain stylistic suggestions, you will be able to use them in other situations.

holidays

We will start with holidays, for the simple reason that this is where your itchy-trigger fingers get the most use during the year. Everyone loves going on holiday and everyone loves taking loads of pictures during relaxed, happy times.

Thankfully, when on holiday a photographer has the chance to see wonderful new things, visit interesting places, witness innovative architecture and generally have a great time. Most of us travel on holiday only once or twice in a year, so getting photos that won't bore your friends (or yourself) to tears when you get back home is of great importance in a photographer's mind.

First, ensure you have ample extra storage devices. If you don't and you have a bumper holiday with a mass of great pictures, it will be all the harder selecting which ones you need to get rid of to give you that little extra space. Taking two cards – one large storage card (32Mb or higher) for a large selection of smaller resolution pictures and a smaller card (16Mb or lower) for taking your very best high-resolution images, of which there are generally less – is a good combination.

Many people make the mistake of shooting places *and* their family. Yes, it's a good idea to shoot as many settings as possible to set the scene and tell the story about your journey. Yes, you also want to look at your family, but how many times have you been abroad and taken about 60 photos of your partner and children? Is it really necessary? Does it say much about your family or

the experiences you've had while you were away? Probably not. Taking pictures of events, local people and real life in the place you are visiting; pictures of your family interacting with this different way of life; trying to check out the less-trodden path instead of just revisiting a few famous landmarks and mixing all these up will grab anyone looking at your photographs and make them interested in where you have been, what you have done. Don't exclude your family, but be very aware that the pictures you take aren't individual pictures, but a record of part of your life experience. Given this, the more effort you put into making the shots interesting, the more you and your family will get out of them in years to come.

One of the most common photographs you will take when you go on holiday is the famous building or monument. Yes, everyone wants to get their family member standing with this piece of history, but most people suffer from forgetting about perspective, with their child standing at the foot of an 80' column. If the person is dwarfed by the building, at least one of your focal points will look out of place. You are not encumbered by film with a digital camera, so why not take several interesting vantage points of the main attraction and then combine the relevant family member alongside one of the more dominant, but more appropriately sized parts of the overall monument. This idea is a common one amongst photographers and it adds a massive amount

Using naturally converging parallel lines such as roads or tracks converging towards a horizon gives a landscape a great sense of depth and perspective.

Using natural reflections gives your photography an added dimension.

of life and energy to your photography. It invites questions – 'What was that she was standing next to?' – and suddenly your photography is communicating instead of boring people.

If you do want to get a complete building or monument and an individual in the same picture, get your family member to move a long way into the foreground, with the building still in focus but far behind, so you get a realistic perspective and a better balanced photograph.

As most of us prefer to holiday where it isn't wet, raining and overcast, you should always check your brightness levels and adjust accordingly. Too many pictures, especially with digital cameras, come out over- or under-exposed because of too much or too little light being available in a scene. Simply modifying the brightness sensitivity, as explained in the section 'Digital-Camera Features In Depth', will give your pictures a better light balance and instantly improve them.

Traditional photographers have had to worry about unwanted people, cars, signposts, planes and so on in their shots. Thanks to the advent of digital photography, you can largely ignore these unwanted elements as they are very easy to remove. We will be looking at techniques for achieving this later in the book.

For the sake of presentation, it is always good to have a couple of departure and homecoming photos as, despite my personal inclination to make every shot a work of art, the photographic intention of most people on holiday is to tell a memorable story. These elements act as good in- and out-points.

Remember, however, that although it is excellent to get pictures of locals in faraway places, not everyone in the world welcomes the intrusive lens of a camera. Don't forget that you are in somebody else's home!

kids

Come on, own up now – this was the only reason you bought a digital camera. You know you are going to go snap mental over the next few years as your children grow up and the price of getting traditional pictures developed would cost you a second mortgage!

Shots of children can often be the most rewarding for the photographer, as babies and young children tend to be some of the most photogenic people around. Because you are going to take several thousand pictures of your children anyway, making sure you get photos which you will be able to look back on and be proud of is essential. Don't just fire and forget: even a minute spent setting up a shot and framing correctly can turn a normal picture into an interesting memory.

One thing many adult photographers forget when taking pictures of children is that their subjects are smaller than they are. They see the world from a different perspective and too many photographs look down on the child from the adult's vantage. Shots suddenly become more real if the camera is brought down a couple of feet to the same level as a child's eyes. If there are adults in the shot, don't worry about the guillotine effect too much, unless the adult was integral to the shot. Always strive to get the best photograph of your main subject; everything else generally works out after that.

We all love pictures of children looking formal, but many pictures show children dolled up as the adult's plaything and the life that radiates from the picture generally decreases accordingly. A better solution is to wait until the child is getting ready for some event – a formal Christmas meal with the rest of the family or a school recital – and then photograph them in their natural form. This can improve the essence of the picture no end.

Children are natural movers; they have a pent-up source of energy that is almost continuously unleashed. Many pictures show the child as static and posing for the camera, but more fluid and natural shots can be achieved by

sneaking a photo of the child in play or interacting with other children. With this kind of photo in your collection, the stark difference between a sleeping or resting child becomes more apparent. These two extremes go well together, rather than a humdrum selection of staid poses.

Another reason many pictures of children fail, even if they contain action or an innovative setting, is because digital-camera users forget to change the white balance on their cameras. A photo of a child playing with play dough in the kitchen could look great, but a picture taken a few minutes later in the lounge, where there is a different ambient temperature or light, can look massively different unless the white balance has been modified to compensate. The earlier section on white balance emphasises the importance of this.

Getting children used to being in front of a camera when young is good too. Early exposure to being photographed and being around cameras means that when children get older they will not be shy or bashful when being photographed, leading to a lifetime of natural, memorable pictures.

groups of people

This is one of the most common types of photograph. When you are looking through people's snaps, they invariably contain stacks of group pictures. Grouped-people pictures can come in different flavours: sports teams, work photographs, holiday scenes and family gatherings.

Generally, the pictures a home digital-camera user will take will be informal, so it is important that you get everybody's co-operation and that you are able to make everyone in the picture feel relaxed. One of the bugbears of having group shots taken is when that idiot behind the camera has you all posing and then takes five minutes to get you to shuffle into the right place, to get that stray arm out of the way, to get everybody in frame – aaaarrrgghh! Even worse is the person who shouts, 'Say cheese', prompting you all to hold your best fake smiles, and then waits another 30 seconds before taking the shot, by which time cheeks are in spasm and people's patience wearing thin! At this point, the same person has to pick up the next person's camera (because they, too, wanted that memorable shot) and the whole agonising process starts all over again!

Please don't do this!

As a photographer, you don't need people to be in shot to be able to plan and organise your shot. The considerations of indoor and outdoor lighting from the earlier chapters is very important. You will be able to work out the optimum

position from which to take the picture very easily. You can also work out in advance where the extremes (left, right, top and bottom) are so you can say to two people, 'You stand on the right there and you stand on the left there, and everyone else fit yourselves in between.' All of a sudden, you aren't moving backwards and forwards, trying to fit everyone in frame. The same principle applies to shooting from an elevated perspective that looks down on a group, when top and bottom extremes are relevant. Indeed, this kind of shot gives group photos a much needed boost of interest.

Having a tripod is great for this kind of photograph, as most digital cameras have some form of self-timer. If you can frame a picture perfectly, it is very easy to get yourself into shot as well, without the problems associated with traditional timers (in my experience they work sporadically at best).

Thinking about where you are taking a group shot is important. If you are taking a group photo of your work colleagues, try to take it at work. If you are taking pictures of your judo team, do it at a sports hall. If you are a rambler, take a picture up a hill. If it's a picture of your nude sunbathing club, don't take them with clothes on! The picture may mean a lot to you and your friends, but in years to come pictures taken out of context lose their impact.

Every group has its own individual character, so you need to use a little initiative. As long as you second-guess as many problems with the shot as you can before the picture is taken, you are more likely to get a good shot.

As for getting everybody to smile at the same time, sometimes you will, sometimes you won't. That's just the way it goes. Just don't make people hold smiles, as faking smiles is something most people aren't that adept at.

weddings

You'll be at a wedding at some point in your life and without a doubt you'll be taking masses of photographs. To take wedding photos successfully, you need to combine a number of skills that aren't usually required for a lot of your digital photography.

The primary concern is making sure people will look their best. With this in mind, you should only ever take wedding photographs with soft focus, or your camera's portrait mode. Making people look natural is also important; weddings are one of the few times you will find almost everybody happy and excited, so getting interesting and natural shots is relatively straightforward.

Without doubt, you will be surplus to any professional event photographer,

but this is a good thing. The professional photographer will have set the bride and various other relatives in positions that capture any available natural light, so positioning yourself behind and to the left or right of the 'main' photographer will yield the best possible results with minimum effort. Also, given that the bride and groom will be hounded by all and sundry to pose for individual shots afterwards, they will do nothing but thank you for not impinging on their special day any more than absolutely necessary.

There are a number of photos which ideally you will strive to capture, for example the traditional full-length shot of the bride wearing her bridal gown and holding a bouquet. Or inside the church, at the moment of union – although you may have to check in advance that photography is permissible. You should always try to avoid flash within a church: if ten people all take flash photos at the moment the newly married couple turn to face the assembled guests, bride and groom will spend the first ten minutes of married life blinded! It has happened to me and more than one or two friends!

Scenes such as the cutting of the cake are very popular, but group pictures of people toasting the newly married couple at the reception are equally atmospheric. Such shots can be difficult to get though as when everyone in a room stands up at the same time, organising a shot without calling a halt to proceedings can be more than difficult. If possible, this kind of shot should be taken at a raised perspective.

Pictures outside the church are the mainstay of wedding photography. The weather is in the lap of the gods, but by applying some of the techniques described in the section 'Shooting In Bad Weather', you will be able to get some good shots even on inclement days. Your own photo requirements will be very different from everybody else's, depending on whether you are a friend or close family. Close family will tend to mean you want the bride, groom, all family members from both sides, bridesmaids and best man. If you are just a friend, try to only capture the relevant pictures, although it is very easy to get caught up in a snapping frenzy!

It is possible to make wedding shots more interesting by the use of simple props, such as blowing bubbles around the bride. This adds a fairy-like quality to the pictures as the bubbles pick up any natural highlights that are available. Shooting the bride and groom with the sun directly behind them can create a lovely atmospheric lens flare (see 'Accidental Effects And How To Recreate Them'), which if positioned correctly gives an almost angelic feel to the photograph.

Always take two or three shots of important moments, as cutting the cake and the like only come around once. Fortunately, mid-range digital cameras

and above can take a batch of up to three shots in rapid succession; the bad ones in the cluster can be removed later. This is a great time to use any autobracketing function on your camera, so you can take three instant shots but at different brightness levels, ensuring that you get at least one with a perfect exposure.

Needless to say, extra storage cards at a wedding are of paramount importance, especially as you will want to take many of the more significant shots at as high a resolution as possible. Weddings (theoretically) only come around once, so it is important to get the shots you want to the best of your ability.

shooting movement and action

It's great when you have a static subject or scene because it allows you to focus properly, make sure you have the correct white balance, brightness sensitivity and correct framing, and gives you all the time in the world to hit that perfect shot.

In the real world, things move and as a digital photographer your ability to capture movement that adds life to a photograph is a much sought-after skill. Like all things, it takes practice, but there are many sensible guidelines which will help you get there just that little bit faster.

Motion and action in photographs can give a great sense of fluidity to a picture. You are either halting a moving object in time as it speeds through its range of motion, creating trapped latent energy, or you are allowing an object to zip through your otherwise static shot, blurring and giving a real sense of speed. These are the two extreme alternatives and everything in between can be captured as well.

High-specification traditional cameras often have the advantage in shooting action shots as there are more models available with the capacity to modify shutter speed. Only the very highest-end digital cameras (professional versions, from the likes of Pentax, Nikon and Fuji) can offer a fully variable shutter-speed function. Mid-range cameras will, however, let you modify the shutter speed slightly. Thankfully, this is enough for you to make either extreme of motion photography look good.

Because your digital camera will have different levels of speed settings, you should try the following techniques with the shutter speed (or shutter sensitivity, as it is referred to by some manufacturers) set at different levels, so you can get a feel for the specifications of your camera and the extent to which these techniques are suitable.

Panning is the camera technique of swinging the camera to follow a moving subject so that the subject stands out well against a blurred background. The object that is being followed remains in focus, while the background will appear blurred as the lens retains focus only for the targeted subject. You can test the panning method well by standing on a busy street, focusing on a car coming towards you and then panning the camera to follow the car. As the car gets nearer to you, its perceived speed will increase. When it gets very close to you, snap and check the image on your LCD display. Even though through your viewfinder the image will have appeared solid, the image should now show a blurred background to the sharp, in-focus car.

Reverse panning, panning in the opposite direction and snapping when the subject comes into view is a way to get extreme blur, instead of complete focus on the car. These two extremes are very simple ways of checking how responsive your camera is to different kinds of motion, and this in turn allows you to plan the kind of action shot you want to take.

Another useful tip is to use a tripod whenever possible for pans, as the panning action of a person's hand is often inaccurate.

It can be good to hit both the extremes of blurring and trapped motion by having all objects within a scene completely frozen in time, such as an athlete doing a long jump being captured mid-flight with the background in perfect focus. This gives a very nice freeze-frame effect and, because of the effects of gravity, you are inherently aware that the athlete is moving. As fast a shutter speed as possible should be used for this kind of shot, but because the athlete is slow in relative terms, you can get away with it. We will look at faking motion in photographs in the second half of the book.

There are also a number of ways of implying motion within static images which can give a real dynamic to an otherwise 'ordinary' picture. The use of 'diagonal' architecture, such as when you are shooting at an angle within a domed train station, gives the impression of movement even though the building is obviously standing still. Anything with parallel lines which slope away from the photographer, such as a square-on photo down a railway track, give the illusion of movement as something stretches away into the distance. Static images like a train which is only partially visible with a track stretching off also give a great feel of action. This kind of shot is a good way for beginners to try to exploit static images with dynamic potential.

Sporting shots are ones which many people try to take and which generally contain action or certainly good potential for some! Slower sports such as football, rugby or horse riding can be taken well with digital cameras, but

sports that contain a lot of fast movement (Formula 1 racing, motorbike racing and the like) can be hard to take unless your camera has an exceptionally fast shutter. The sports can be shot, but most would come out as a blur.

In sports photography, the pre-focus is an essential technique to master. Pre-focusing is having a specific but empty part of a shot perfectly in focus, with the intention of waiting until your subject crosses the point of focus. You then take the picture and a rapidly moving object becomes much easier to capture. The panning techniques we talked about earlier are very useful for most sports and can add a lot of dynamic potential to an otherwise lacklustre spectacle.

A good-quality optical zoom is a way to get close to movement or action that would otherwise be impossible. You would be surprised at how close you can actually get with a meagre 3X optical zoom, which comes as standard on most digital cameras.

shooting stage shows, big events and concerts

Big events have their own problems for the digital photographer to overcome, not least of which is how to photograph without disturbing any of the performers. Generally, you will be stuck in your seat and not have the ability to move around without disturbing everyone around you. This means you can be very restricted in the kind of photos you take and many stylistic considerations and angles you may otherwise have preferred will be unavailable to you.

Equally important, many shows – especially large West End productions in London – will not permit public photography: one, so the performers don't get disturbed or 'flashed' by an overzealous snapper and two, so you buy the programme! You can get away with this to an extent if the show is over and the performers are taking their bows, but you may find yourself being questioned by security. I know I have!

For smaller-scale productions, you may find that organisers actively endorse the taking of pictures, as any publicity – even to friends and family – is good publicity. No flash is the key though. Most stage shows, even the lower-scale, local productions, will have adequate lighting on the stage. Because the light is focused to highlight all the important elements of a scene, flash photography should not be needed anyway. Always modify your white balance though, or a well-lit stage may turn into a dark and murky photograph.

Regardless of the scale of the production, if you haven't seen the play or aren't familiar with the script and events within the production, you are unlikely to

be able to anticipate when certain key events are going to happen. This is another reason producers aren't keen on cameras as any flashes or disturbance at just the wrong moment can spoil a complex production for everyone else. If, on the other hand, you do know a script and play inside out, you may well be able to prefocus on an area without using a flash, so the moment a certain event happens you are already poised. This is a way to sneak around camera restrictions, but make sure you are subtle.

Pop and rock concerts are generally a little more laid back, although in the throng of a moshing crowd, you may want to think twice about bringing your expensive digital camera and opt for a throwaway single-use camera with a built-in flash. We will be looking at how to enhance this kind of picture in the second half of the book. Also, if you are far away from the mêlée at the front of the concert, you will find it difficult to focus on any specific feature on the stage, so this is where your optical zoom and, to a lesser extent, interpolated digital zoom, will become important.

Thanks to the lighting at most modern rock concerts, flashes coming from the audience are generally fine, although they will have little impact on the outcome of your shot unless you are very close to the front of the stage. Despite light being very dominant on the focal point (the band) and occasional light sweeping over the crowd, you will still need to adjust your brightness to accommodate the conditions.

Because of the inherent difficulty in shooting a stage show or concert, this is one of the few times I would not recommend trying anything too fancy. Simply capturing a basic scene as best you can and then altering brightness levels and colour balance in your image-editing suite can be the best way to record such a memory.

accidental effects and how to recreate them

Accidental effects happen by chance and can ruin an otherwise good photo. Equally, that elusive lens flare in the right place can turn an ordinary picture into something quite special.

By learning how to recreate fluke shots, even non-manipulated photographs can appear to take on a life of their own.

Lucky mistakes with digital cameras are less frequent than for traditional cameras, because of the generally smaller lenses. Also, low-end cameras with a fixed-focus lens produce fewer such effects because of the inflexibility of the image sensor.

You should experiment with these techniques for producing some excellent 'accidental' effects until they become second nature. Even though most of the tricks of the light can be easily reproduced in an image-editing package, if you can achieve most of what you want with your initial photograph, you've already knocked out half the workload!

These are just a small sample of the crazy effects that light can have on your images. The unexpected isn't always a bad thing. Just remember that if you get an unexpected effect, don't just delete the image and re-shoot. Think about the circumstances which produced the unexpected effect and see if you can recreate the effect. Then a time will come when that effect is the thing that will make a picture, and only you will have that elusive knowledge!

shimmering oceans

This effect occurs in badly lit scenes, generally outside and where there are many highlights and shadows (very light and very dark regions) in an image. The lack of mid-tone colours give very distinct and sharp areas of contrast which result in a very atmospheric, stark and dramatic image. This can best be recreated when using a normal landscape mode for your image, so the edges where there are high levels of contrast are rendered particularly sharp. If you were to use a night-scene function, where the exposure is taken over a longer duration, the movement of the waves would create some ghosting, which would remove some of the sharpness that makes such an image so inviting.

lens flare

Lens flare is one of those effects that is seen everywhere, an awful lot of the time added as an afterthought in an image-editing package. Despite looking thoroughly believable, there's nothing quite like getting a real lens flare that looks really cool in one of your pictures. Getting one that will work, however, is something of an art in itself.

Lens flare arises when a bright light source is refracted through the lens, splitting up at the point it hits the CCD image sensor, giving a bright halo at the source and any number of light globules in any direction. The shape of your lens flare depends on the size and quality of your lens. This effect can often be achieved when light is shining almost directly into the lens from any point on the visible horizon. You will not always be able to tell if there is going to be lens flare on your exposure as you look through the viewfinder, which allows light through differently to the lens. As long as you know the sun (or another strong light source) is shining fully into the lens, you should be able

to get some form of flare. Experiment with this kind of operation until you get used to it, and remember that with such bright light shining into your lens, the main subjects of your picture will remain several tones darker – so it may well be worth modifying the brightness settings on your camera after taking an initial test shot.

matte subjects

This is an unusual effect that isn't so much an accident as a cheat. It occurs when the sun or other strong directional light source is shining directly at the camera lens from above, in much the same way as for lens flare, thus flooding the entire image and the subject with strong light. The effect occurs when there is an obstruction above the camera lens (a piece of simple cardboard will usually suffice). This then blocks out the harsh light that would have been recorded in the lens, while the subject and surrounding scene are so flooded that contrast is almost eliminated and colours are brought into merged harmony: great for making sepia-toned images without the special lenses traditional photographers normally have as part of their arsenal.

earthquake

In a nutshell, this is camera shake. Hit a few coffees before taking your shot and your hand may well be a little shaky, and when you take your image so will the elements that make up the scene. However, to create a really nice earthquake effect in your camera, turn on the camera's equivalent of the night-scene function. This will give a very slow exposure time, meaning any movement of objects – or your hand – will be very marked on the final image, giving the

Intense highlight and shadows combined with fast shutter speeds can grab vivid highlights and make for interesting textured effects.

Lens flare is one of the easiest effects to capture, but just remember not to stare directly into the sun. Going blind for a photograph isn't big and it isn't clever!

effect of intense movement within the scene. Because night-scene functions are automatically set to take in maximum light, if you are taking a day shot you should manually adjust the brightness level to counteract the extra length of exposure time. Different settings will also yield different colourings of your subjects, which will vary depending on your camera.

neon streaker

This is almost the opposite of the 'earthquake' effect. This time, you want your camera to remain still and there to be many brightly lit, fast-moving objects within your scene, such as cars rushing along at night on a motorway. Using night scene again, with the slow exposure time, the brightly lit moving objects will leave a ghostly neon trail in their wake when the picture is finished.

If your camera is particularly advanced, you may be lucky enough to be able to set the exposure time manually, so instead of a uniform night-shot time of up to three seconds, you could set the timer manually for eight seconds and get a truly hypnotising effect. This functionality will only be available on very high-end digital cameras.

For this kind of effect to work, it is important that your camera remains still during the exposure, so a tripod is well worth considering.

shooting with style

Well, you now know everything your camera does to light to make digital photographs. You also know the whys and wherefores of the more techy things relating to picture taking: lenses, zooms, apertures and the like. You know how to make the most of these elements to give you impressive pictures. But having the technical knowledge doesn't mean you are going to be able to shoot with style.

You know when you are handing round a selection of photos to friends, family and colleagues and they dutifully look through, umming, ahhing and feigning interest as yet another group shot of three unknown people hug each other and smile at the camera? That kind of shot bores everyone to tears other than the people actually in the photograph. There is nothing wrong with repeated shots of friends, but don't you think you owe it to yourself and anyone else who intends to look at them to think about taking slightly more innovative shots? For starters, you and your friends (or whatever the subject is) will have more fun when you are taking the shot anyway, but changing perspective, squatting low or getting a high vantage point, taking an instant shot that the subjects were unprepared for, rotating your camera to change the alignment of the final exposure – all these things and more add interest to a shot. Even if the photo is a right royal cock-up, that doesn't matter. With digital photography you can re-shoot as many times as you like!

A Turkish or Californian guitar amplifier? No, by turning on the night-scene function and moving slightly, you can make out that an earthquake has just hit your living room. Because of the extra exposure time, the image will be lighter than normal, so remember to manually adjust your brightness settings first!

The point is, as soon as you start taking some stylistic initiative with your photographs, you won't stop. Every time you try something different, you get a new idea, every time you get a new idea, you get inspired, every time you shoot with a little inspiration, those ummers and ahhers will suddenly start genuinely taking an interest in your images and you're one step closer to becoming the photographer you always wanted to be!

Now go out, put this advice into effect and get shooting!

image manipulation

selecting suitable software

Computer software is essential for fiddling with your digital photographs after you have taken them and got them on to your computer. Thankfully, all digital cameras come with the software required for downloading your pictures to your computer's hard drive and also for viewing them afterwards. Unless you have a more expensive digital camera, however, that is likely to be about it for your software, which leaves you with nothing for all the fun stuff.

You may well have heard of Photoshop, which is the *de facto* standard in image-editing software and is used by most digital-photography professionals. This is expensive, but there is a trimmed-down version available. For the image-editing and manipulation we will be doing in the practical section of this book, we will be using Photoshop, but all the skills are fully transferable. Using the industry standard software is always the best way of learning the 'proper' techniques for manipulating images.

After you have finished the following tuition, you will have a much better idea about which techniques you will want to employ on a regular basis, and thus will know whether you need a full version of Photoshop, its trimmed-down version, Photoshop Elements, or one of the lower-priced, but feature-rich shareware solutions. Shareware software will either allow you unrestricted use of the software for non-business use or give you the full software for a limited time, after which a cheap licence can be purchased. Solutions like PaintShop Pro or any of the Corel image editors are all excellent and inexpensive Photoshop alternatives.

As the tutorials in this section are designed for use with Photoshop, we will assume you have installed the fully functional demo version from the cover CD.

transferring digital photos to your computer

Every make and model of digital camera comes with different software. The software will take the form of a set of *drivers*, an image-viewing piece of

software and possibly an editing package, the quality of which will vary depending on the price of your camera. *Drivers* are small pieces of computer code that allow your computer to recognise a piece of hardware, in this case a digital camera. Before you can transfer any pictures from your camera to your computer, you need to install these drivers.

On both PC and Mac, when you insert the CD that contains the necessary software, it should immediately kick in and ask you if you want to install the relevant software. If this is not the case, you can attach your camera to your computer via the USB port and turn it on. When the digital camera is turned on you, the computer will recognise that there is a new piece of hardware attached to it and ask you to tell it where the relevant drivers are. Tell it to look at your CD drive and the correct driver will automatically be selected.

After this point, your PC or Mac will recognise your camera as being a new hard drive (hard drives are the very fast disks inside your computer that store the operating system your computer actually works with), and may be referred to by your computer as a 'mass storage device'.

On a Mac, your new mass storage device folder will appear on your desktop. You can then drag images from within this folder elsewhere on your computer, where they will be stored. On a Windows-based PC, right click your mouse on 'start' and click 'explore'. You will see a drive on the left partition of your screen called 'removable drive'. Double click this and you will see image files which can then be dragged or copied and pasted elsewhere on your computer.

This is the hardest way to transfer digital photographs to your computer; you will be pleased to know that 99 times out of 100, you will only have to insert the software CD which came with the computer, click 'OK' a few times and then, when you attach your camera to your computer with the USB cable, a software viewer will automatically appear and you can browse till your heart's content.

considerations when working with digital photo files

Images stored in your camera have been digitised and converted to a graphical format which can be read by your computer. These images have a file size, which can be likened to a person's weight. Low-resolution images (640 X 480, for example) are very light and not very 'fat', so you can store thousands and thousands on your computer, work with them very easily in an image-editing package and transfer them very quickly from your camera to your computer. The moment you start working with mega-pixel files, the size of these images goes up dramatically.

A 640 X 480 JPEG image from your camera can be as small as 70Kb (kilobytes), a 1,280 X 960 image is large (600Kb), but is still fine for fairly low-specification computers, whereas a large mega-pixel image at 2,400 X 1,800 suddenly increases its weight exponentially, becoming 2.5Mb. You have a limited amount of space on a computer hard drive, so it is worth considering restricting the amount of very large mega-pixel images you store on your computer.

the JPEG digital image format

Most cameras use the worldwide JPEG standard, which is actually a type of compressor created by the Joint Photographic Experts Group. It takes a very large initial amount of data mapped from the CCD sensor and converts it to a map of coloured pixels. This map of coloured pixels is then compressed (as untreated data gives very large file sizes) and the whole thing is given a .JPG extension to its name, so you and your computer can tell the file is a graphic. JPEG is a variable compression algorithm, meaning you can either have very high-quality JPEG images, which have a larger file size, or lower quality images which may have slightly mottled edges in areas of contrasting colour, but which have a subsequently useful drop in file size. Many digital cameras allow you to take photos at a certain resolution and also let you set whether you want basic, medium or fine quality. What they are actually asking is whether you want the JPEG compression set to 40%, 70% or 100%. With this in mind it is good, if your storage card allows it, to always record your images at the best level of quality you can and alter the size and quality of the photo in your image-editing package afterwards. If you select a lower quality level, then re-save an edited image within your image-editing software, you force two lots of glossy compression on to your image and there is a cumulative loss of image quality.

There are many other image formats, all of which have their respective uses: GIFs are losses but can only display a certain amount of colours; TIFFs are very high quality and can contain alpha channels but are very large; and PSDs are native to Photoshop but can contain alpha channels, extra layers, author information, image notes and more. These are the four types of image format you will come across most regularly, but hundreds exist.

Digital images, as we have already discussed, are created from a stream of binary data that is converted to a pixel map and stored, but there is more than that to the images actually created. Colour images are made up of the primary colours of light, which are red, green and blue (red, yellow and blue are the primary colours for paint and pigmentation). Each of these three colours are a separate channel. So each colour image has three channels which contain data that possesses a lightness value from 0 to 255, with 0

being black and 255 white. The data value for each pixel has a size of 8 bits, so with three channels per image, you have a 24-bit image which is a combination of three greyscale images that combine to form a full-colour image. This may seem a little convoluted, but this method allows for the manipulation of digital imagery.

Imagine that whenever you are working on an image within an image-editing package and you modify something, the computer is actually altering the values of the channels that range from 0 to 255 mathematically. So to make the blue channel of an image (the part of an image which contains all the blue hues) lighter, the computer simply adds to the number so the blue hues are all closer to the completely white value of 255. This is just a brief example so you understand the absolute root basics of how a digital image works; I'll try to avoid any more over-techy information!

One final thing... Some images, particularly PNGs and TIFFs, are 32-bit images as they have another channel, known as an alpha channel. This channel contains hidden data and is again 8 bits in size. It uses a greyscale image again, this time with black and white areas denoting 'holes' in an image, so a white circle in the alpha channel would create a transparent hole in the final image. This kind of image is generally used in television where images need to be different shapes, not just square or rectangular.

outlets for distribution

By distribution I mean the ways in which you have the ability to communicate your photography to other people. Traditional cameras have a very obvious outlet for distribution: photographs are simply printed and displayed. As with cameras, these days all methods of communication are digital and there are a raft of possible options by which you can show others your photographic work.

There are different things to be taken into consideration for each of the methods and ways of improving the manner in which you communicate your images.

e-mail

Too many people have very little or no knowledge about digital-image file sizes. How many times have you wondered why your e-mail is taking two hours to download from your e-mail provider's server, only to find that there was one message weighing in at 5Mb or something ridiculous? Worse still, you didn't even want to see it anyway!

Open Photoshop and go to the File menu. Navigate to the CD-ROM and find the 'Outlets' folder and open the picture 'image 1.psd'. You can see that this is a medium-sized photograph in terms of how large a resolution we could have shot it in, but it still packs a hefty-sized punch, weighing in at 4.2Mb. This file would take over ten minutes to download even on a fairly fast ISDN connection. Even people who use ADSL Broadband may find they have to wait a while if they are using the internet at a busy time, so we need to employ a technique which can radically alter the size of the image, thus making it suitable for e-mail distribution.

Go to the File menu and click 'save for web', or use the keyboard shortcut 'Alt + Shift + Ctrl + S'. This feature of Photoshop allows you to compare up to four variations of compression methods to find the one that gives your image a suitable level of quality, while reducing your file size as much as possible. Click on the tab at the top of the screen that says '4 up'.

The top-left image always shows the original and the size it would be in the format it is going to convert to if no compression was added. Even

uncompressed, changing the initial file from a .PSD file to a .JPG image has shrunk the image from a gargantuan 4.2Mb to a more manageable, but still far too large, 1.43Mb. Click on the top-left image and look at the settings box on the right-hand side of the screen. We want JPEG displayed. If you see GIF or PNG 8 or 24 displayed, click in the dropdown box and select 'JPEG'. From the 'quality' box, use the slider and select '80%'. Now click in the bottom left-hand pane and set the quality level to 50%. In the bottom-right pane, go right down to 20%. You may not notice a huge amount actually happening, but if you look very closely at the images, you will see that they have actually degraded quite a lot, especially the 50% and 20% quality images, and the corresponding drop in file size is massive. The 80% quality looks almost as good as the compressed image. Although the file size of 290Kb is not too bad, if you are sending more than one image it all adds up very quickly. The middle-sized image at 150Kb is ideal if sending just the one image, as it is unlikely anybody would be able to differentiate between the two. If you are sending many images, however, as people do, then a quality level of 20% will give you just about suitable quality and a minimal file size of just 80Kb, which is suitable for sending up to four images in one e-mail. You can see that without adding this kind of compression, you could be subjecting your friends and family to a half-hour wait before the e-mail gets through. You will also notice at the bottom of each shot there is a length of time in seconds, an '@' symbol and 28.8Kb. This is referring to how long it would take to download on one of the dial-up modems that are virtually defunct. The minimum in most western countries is 56Kb and you can't buy a slower modem for love nor money now. Right click on the 150Kb image. A menu will appear. Select the 128Kb option. This refers to the speed of an ISDN line, which is fast becoming the 'bottom-level' standard in Europe and has been in America for some time. Now you get a better idea for exactly how long it will take the image to be sent via e-mail over the internet.

One of the features that is often overlooked here is the image-size option. Underneath the settings menus, click the 'image size' tab. You will see you have some options that allow you to resize the overall image. The initial image here was at a resolution of 800 X 624. This is actually very large for an image, providing the image is only intended to be seen on a computer screen and not printed out at photographic quality at a later date. By cutting the size of the image's width from 800 to 600, a 75% reduction, the file size actually reduces by slightly more than half, with the previous 150Kb image becoming 80Kb while all the detail on the picture remains more than adequate. Going one step further and cutting the size from 800 to 400 actually reduces the file size to just 25Kb (enough for you to send almost an entire photo album by a single e-mail), but if subjects of the photos aren't particularly large, you may find people squinting a lot!

Top tip: Most people get lumbered with whatever people send them on e-mail, especially when it comes to larger images. Follow these quick instructions and you can make sure you never have to put up with huge images again! If you use Outlook Express or Outlook as your main e-mail handler there are some ways you can stop downloading any files that are above a certain size. Setting this level at 2Mb is more than adequate as it is unlikely most people will be sending images (or other files) this large anyway, and on that one occasion when your Gran accidentally sends a 20Mb file, then your digital set-up won't be crippled for the next two days!

Open Outlook Express (I am using Outlook Express as this is the most popular non web-based e-mail handler in the world. The technique is the same for standard Outlook.) Click on the Tools menu at the top of the screen and select 'tools', 'message rules' and 'mail'. Now click 'new'.

You will see four boxes. At the bottom where you name your mail rule, call it 'e-mail size limit'. In the first box, scroll down the potential options and check

the box that says 'where the message size is more than size'. When this is checked, there is a change in the 'message rules' box. Click on the blue text that says 'size' and set the size to 2,000Kb, more commonly recognised as 2Mb. Now, in the second box check the box 'do not download it from the server'. If you like you can select 'delete it from the server' as well, but this would prevent you from ever seeing what the file was. With the not downloading option, you can turn the rule off, before you go to bed perhaps, and download any very large files that have been stacking up during the night. Selecting 'delete it' won't work, as it will still download from the server, taking ages, and then will be deleted before you get to see it!

There you go; no more annoying large e-mails spoiling your mood!

CD-ROM

This form of distribution is becoming more and more popular as most new computers have a CD writer (some even have a DVD writer). This means that anyone can cut a CD filled with very high-quality, very high-resolution images,

simply by using the CD-burning program that came with your computer or writer. However, this does lead to a lot of faffing around for the end user. If you burn to a CD, ensure that the end user understands how to navigate through a CD and open images. Fortunately, even if a person who receives a CD full of images hasn't got any image-editing software, they will be able to view the files (as long as they are in JPEG or GIF format) in any web browse. This means you can be guaranteed that 99.9% of computers will be able to see your images.

internet

Many people like to set up web sites that enable anyone they know to go to a web page and view their pictures. Of course, it takes a lot of skill and programming knowledge to be able to do that...doesn't it?

On your computer desktop, create a folder called 'gallery'. On a PC you can do this by right clicking your mouse button on the screen and selecting 'new folder'. Mac users, simply hold your single mouse button down for about a second and a similar menu will become available. Double click on the newly created 'gallery' menu to open the folder. Now connect your digital camera to your computer and transfer your pictures to the folder you created.

Open Photoshop, click on the File menu at the top of the screen. Now click on 'automate' and then 'web photo gallery'. In 'name' type 'online photo gallery' and select horizontal frame from the Style dropdown menu. Where it says 'source', click the button. Navigate to the 'gallery' folder you created on your desktop. Now click where it says banner and scroll down to the next option, 'gallery images'. Set 'border size' to 1, and set 'quality' to 6. The resize image option should be left at 350, meaning it will resize all images within the folder to a width of 350 pixels. Any larger and it can take quite a while for your web page to load if you aren't on a fast connection. Click on the dropdown menu again and select 'gallery thumbnails'. Thumbnails are smaller versions of your images which can be viewed much faster and clicked on to reveal your main images. Here you can select to have the photo's name as a caption by the image. If you check this option you should manually alter the names of all the image files within the 'gallery' folder you created, as digital cameras place a sequential number for the image name, with some letters related to the camera model you took them with. 'DSCFOO1335' doesn't make a great caption; 'Me scaling the north face of the Eiger', on the other hand, does!

Finally, click 'custom colours'. I always prefer a solid black background, as when you are staring at a bright white computer monitor you can go a bit cross-eyed very quickly. With a black background, light yellow text works very well; again, the white on black can be a little harsh. The perfect colour for the text is made

by setting red to 255, green to 255 and blue to 204. Set all links to a light green, red 204, green 255 and blue 204. Set the banner to red 102, green 102 and blue 102 to complete an attractive looking web album. One final task remains: to set the destination directory. This is where everything 'technical' for the web album to work will be placed. Navigate to your desktop when you click 'destination' and create a new folder called 'finished album'. Then click 'OK'.

Photoshop will now will appear to go nuts for a few seconds while it resizes and compresses the images, creates the thumbnails and programs the code

needed to make it all work. Then your web browser will launch. Have a play! Within the web-album directory are all your images, thumbnails and the actual pages containing the code. You can double click on the 'web album' folder now on your desktop and then double click on the 'frameset' file to open your album.

To place it online, go to one of the major internet providers (Yahoo, Freeserve, Lycos and the like) and sign up for some free web space. There will be a link to some free software that will allow you to upload to your web space and you will be given a specific web address that you can e-mail to people so they can check out your shots. Simply upload the entire contents of the folder! Now, that wasn't that tricky – was it?

printed photographs

Ah, the curse of digital photography! Despite all the massive changes and technological advances that have been made over the past few years, people still want to be able to print out photos that look like photos, have the same quality as photos and to all intents and purposes – are photos! That means you need to be able to create photographs and for that you need a printer attached to your computer. All colour printers made within the past three years have the ability to print so finely that the human eye will not be able to tell the difference between what you are printing and a photograph which has been printed from a film in a traditional camera. The problem for most people is that when they have opened up their photos in their computer and tried to print, they turn out to have horrible colours or look blocky and pixelated. The first problem is easily solvable. Each printer's individual manufacturer markets its own special glossy-coated blank paper, which is very similar to the thickness and surface of paper that traditional photos are printed on. Using a generic paper or one from a different printer manufacturer will work, but generally the quality is lower and the ink from the printer may not hold well, may crack or may print a different colour to the one you were expecting.

The second problem is more common and arises from a lack of understanding of the way computers and printers deal with images. Televisions and monitors have a fixed amount of pixels (a word made from picture cells). There are 72 of these pixels, squared, per inch. This is the screen resolution. If you look closely at a television screen or a monitor, you will see that pixels are occupied by a single coloured pixel which is refreshed with a new colour very rapidly; on screens this gives the illusion of movement. Even on a word-processing package where there is not much movement, the screen is refreshing at speeds of over 9,300Hz per second. If you were to print an image though, at this 72-dpi (dots/pixels per inch) resolution, the pixels would be magnified to an equivalent size on a piece of paper, where the 72 pixels per inch would become

very noticeable and give a blocky, pixelated look to your images. The question is, how do we get around this?

Fortunately, your digital camera already has. It's only a bit of miscommunication in the middle which is preventing you from getting perfect quality photographs printed out of your machine!

Open Photoshop. Go to the File menu and select 'open file'. Navigate to 'outlets' from the CD-ROM and select 'image 2.jpg'. This is a very large picture which we are going to print to photograph quality. Initially, the image's resolution is 1,280 X 960 and has an automatic screen resolution of 72dpi. Fine for a screen; bad for a printer. We need to create a document which has the resolution of 300dpi built into it. Press 'Ctrl + n' or go to the File menu and click 'new' to create a new image. First set the resolution to 300 pixels per inch. In the dropdown boxes, select the unit of measurement to be centimetres, the width to be 21 and the height 29.7. This is a standard A4-sized piece of paper, the most common size for a piece of glossy photo paper you are likely to be printing on. Now click 'OK'.

You will see a new empty white document in the shape of an A4 sheet of paper overlap the photograph we opened. Press 'V' to enter the standard select mode, represented by an arrow in the toolbox on the left-hand side of the screen. Click on the initial photograph and drag it into the new white document.

You will see the image appears to shrink considerably. This is because it has been made approximately four times smaller (72dpi converted to 300dpi) to the human eye. Now all the information we could see very large on screen at 72dpi has been squashed to fit 300 pixels in every inch. This means that when you print, you won't get a horrible blocky covering to your photos but a photograph-quality print.

Now, in the File menu at the top of the screen, click 'print' and a new dialog box appears. Setting the image to the correct resolution was only the start. There are built-in options which can further enhance the overall quality of your images.

From this new Print menu, select 'set-up'. The next menu is 'Page Set-up'. Check the name of your printer and that the size of the paper is set to A4 and the orientation is portrait (ie the width is shorter than the length and not vice versa). Now click 'properties'. This is the most important part of the printing set-up process. You must select the specific type of paper you intend to print on, from glossy photo paper to ink-jet to normal. The paper you select will determine how the printer mixes colour for printing and will have a marked effect on the final quality of your printed photograph. Also, select 'colour' (unless you want to print in black and white) and select 'quality' instead of 'speed'. This final setting is slower and uses more ink but gives a perfect photo finish. Some printers may have different specific options, but those described above are fairly universal.

Now you can print and, as if by magic, all your blocky picture problems will have disappeared. When printing out on an A4 glossy sheet, it is always wise to fit as many pictures on the page as possible.

practical image manipulation

what is image manipulation?

In pre-digital days, images were manipulated by an artist with an airbrush. Fine-coloured inks were sprayed over blemishes and wrinkles to give an illusion of perfection. These days, airbrushing is still popular, but more with hobbyists. This is because the speed at which images can be airbrushed and the infinite variety of techniques and looks that can be achieved mean that, as with traditional cameras, manual airbrushing is a thing of the past.

Given the penetration of computers and digital-imagery software into every aspect of our lives, image manipulation is now absolutely everywhere. People don't like to admit it, but reality isn't all that interesting. Would you rather see a gorgeous, perfect model (male or female!) or one with slightly iffy skin, blemishes and wrinkles? Maybe the latter for novelty value, but perfection is where the money is. I used to work in a magazine post-production house, and you really wouldn't believe what the likes of Brad Pitt, Jennifer Aniston and Lisa Kudrow look like before they have had their images smoothed out, re-coloured and much, much more. Every image you see in a paper, magazine, on a billboard, on a flyer has been modified – and usually nobody knows the difference. If superstars, products, places in brochures and more have all been digitally 'manipulated' then by learning a few rudimentary techniques you can do things to your digital images worthy of the front page of the magazine.

Image manipulation itself can be anything. It can be simply modifying the overall brightness of a picture, as your digital camera does when you modify its EV, to going right down to the smallest possible pixels and removing hairline wrinkles, adding filters to change the overall look, cutting people out of a background and seamlessly merging them into a place they have never been. These days, when you have mastered the basic tools, the only limit is your imagination. It may be something of a cliché, but by the end of this chapter, you will be able to do all the above and much, much more. My wife would hate me to admit it (I'm banking on her never reading this book) but she even modified our wedding photos before showing them to her family in the Czech Republic. Nobody had a clue!

how to remove unwanted items in pictures

One of the most common techniques for a digital-manipulation master is removing unwanted elements from a picture: that pylon that looks as if it's sticking out of the top of your head, a 'For Sale' sign outside a historical building, a car in the wrong place at the wrong time... Even though, with careful photography in the first place, such pitfalls can easily be avoided, sometimes certain elements haven't been seen or couldn't be avoided.

Open the File menu in Photoshop and click 'open file'. Navigate to the Tutorials folder on the CD-ROM and open 'image 1.jpg' from the 'how to remove unwanted items in pictures' sub-folder. You can see a nice landscape that some fool has left a street light in the middle of, spoiling the ambience somewhat. We want to remove this erroneous lamp.

First, we need to be able to see what we are removing a little more clearly. Press 'Z' to activate the zoom command and circle the street lamp, or click on the button that looks like a miniature magnifying glass on the left-hand

side of the screen. For future reference, you can easily find out the names of the tools on the left of the screen by hovering your mouse pointer over one of them for a few seconds. Now click above and to the left of the offending

street light and hold the left mouse button down. Move your mouse to the bottom-right of the street lamp, drawing a box, and let go of the mouse button. You will see you have zoomed into the street light. If you go too far you can press 'Alt' (PC) or the 'Apple' key on a Mac (I will only refer to 'Alt' for future reference) to zoom back out again.

Now we have zoomed in, we need to select a brush to paint with. Press 'P' to activate the brush command. Click on the brush displayed at the top of the screen and a box will drop down with different sizes and shapes of brushes. Select the 15-pixel soft brush.

Now we have selected a brush size and shape, we want to turn on the clone stamp tool, which is the fundamental means by which most unwanted elements are removed from photographs. Press 'S' to activate this tool, or click on the button that looks like a rubber stamp on the left of the screen.

Now comes the sneakiness. To remove an item, you cannot simply copy and paste an area over another area of a picture, as there will be obvious 'hard' edges around the area in question. Instead, we use the contour of the soft brush we selected so that we can copy from one area of the picture and 'draw' this area directly over the other area. Don't panic! This will all make perfect sense in a second.

To get the idea, I will show you an obvious example within the same picture before we try to remove every trace of the street lamp. Press the 'Alt' key. You'll see the cursor replaced by the clone stamp icon. Click on the top head of the street lamp and let go of the mouse. Now move the mouse to the blue region to the right of the lamp, click your mouse, hold it down and move it around: you'll see it drawing a new street-light head. What's actually happening is that the tool is cloning the area where the stamp tool was and putting it in a new place.

Now press 'Ctrl + Z' to undo the clone, or go to the Edit menu at the top of the screen and select the 'undo' option. Now we want to clone the light blue sky areas from around the edge of the street lamp and draw over the lamp, removing it from the scene. Again, position your mouse over some of the clear sky around the street lamp, press 'Alt' and click your mouse to set the clone position. Then draw over the street lamp. Easy as that. After every few clicks of the clone stamp, you should reposition the starting point of the clone tool with 'Alt'. Varying the size of the brush allows you, with a larger brush, to clone large areas quickly, while a small brush, or a small brush with harder edges, allows you to clone areas that require more detail.

There is one final element of the image which isn't up to scratch: the electric wire hanging just in shot from an overhead pylon. Again, position the source point of the rubber-stamp tool with the 'Alt' key and draw along the length of the wire, covering it with the similarly coloured skyline just below. After you have made this initial long sweep, you can reposition the source and tidy up the edges near the clouds to give the impression of perfection. There you go. You've just become a digital manipulator! But to make sure your skills will

stand the test of time, we will practise on a more complex image. You can open the image from the CD-ROM called 'image 1 finished.jpg', from the same folder.

Click on the 'X' at the top right-hand side of the image to close it. Now open 'image 2.jpg' from the same folder. It's a lovely farmhouse that somebody

had the gall to paint pink. However, you can see some unsightly white wire coiled in a gap in the right-hand wall, and we aren't too keen on seeing the name plaque either. With a little care, both can be removed. With the image open, press 'Z' to open the zoom commands, and zoom in on the white coiled wire (circled).

Now set the brush as for the first example, but this time select a smaller brush. I would recommend the 3-pixel hard round brush, which is small enough to allow us to clone the cement without taking too much brick colour from either side.

The circled areas show you the point I cloned from and also where I started cloning. I was careful to draw in very accurately the shape of the brick and ensured that I joined up the layers of cement before colouring-in the brick with the cloned brick from above.

So it doesn't look as if part of the wall has actually been cloned, you should then move the clone tool to a different brick that looks about the right size to fill in the remaining gap. Press 'Alt + Z' and click to zoom back out and admire your handiwork.

Now for the hard part. Zoom in on the 'Wheatley's' sign; we are going to remove it and replace it with a complete wall. To get away with not doing too much work you want to pick a larger, soft-edged brush. Try the 21-pixel soft brush.

The sign disappears like an absolute dream. You will find that around the edges of the area you have cloned over, there are some small discrepancies. Revert to a smaller, harder-edged brush, and delicately cover the contours by cloning the line of cement from another region of the picture. Very easy; very impressive. If you can remove a solid sign from a brick wall, just think what you could do to Brad Pitt!

Now open 'image 3.jpg' from the same folder. You should be getting a feel for the power of the rubber-stamp tool now. One of the most common applications for this kind of tool is removing erroneous people when they detract from an image. In this scene we are going to try to second-guess what is behind the actual subject of the image and remove her, but also remove the smaller people in the back left-hand side of the image, leaving nothing but an unspoilt landscape. This is a tricky tutorial and should ideally be attempted in one sitting.

First, we remove the small people: they are easy. The hardest part of this is getting the contours of the detailed areas of the picture to flow evenly, giving the false illusion of an unbroken line. With this in mind, let us begin with the smallest of the people in the background, as the group of two men has a clear

line from the path crossing him. On the screenshot the order in which we are going to tackle the groups is listed. We start at one.

Press 'S' to access the rubber-stamp tool and select a brush from the top of the screen, as before. Select a small but soft brush initially. I have selected a 9-pixel soft round brush. Zoom into the area occupied by the man. Start by pressing 'Alt' and clicking your mouse button just to the left of the small group, cloning to the middle of them. Then 'Alt' and click on the right of the group to select another initial source point for the tool.

We do this as there is a marked difference in the subtle shades of the grass on the hill behind the group. If we were just to clone in one direction, there would be a clear 'edge' to where the group was cloned out of the picture; and remember, digital manipulation is all about creating the perfect illusion.

To keep the line of the path perfectly straight, make sure that when you perform your clone operation you move the point you intend to clone directly horizontally to where you selected the source. If you do not do this, the line of the path will be too high or too low, making for a poor clone and ruining the image.

When you have cloned out the people, we need to 'fix' the clone to make the illusion work properly. There is a professional technique called random cloning, which we will use. We use this technique when we don't quite know what is behind the elements we are cloning out. This means that we have to interpolate not just the detail that *should* be present, but also the colorisation. Because we can't tell which greens should be present when the people are cloned out, set source points to the locations circled in the screenshot and make a small clone with one single click of the mouse. The build-up of the four separate clone points will produce a believable colour variation in the new area we have created.

Building up these 'random' greens forms a perfect overlay. Now let us move on to the second group of people, where we have their individual stylistic problems to overcome. This time, we need to perform a similar two-sided clone, as with the first group, but you will see the shading on the path above and to the right of the group is significantly lighter than the part of the path to the bottom and to the left of the group.

Begin by setting a clone point and carefully begin to chip away at either side of the group until the two different coloured parts meet in the middle. Don't

fully remove the group. The way to get both of the different coloured parts of the path to merge believably is quite clever, even if I do say so myself! For the remaining top-right part of the detail of the group, make a clone point from the bottom-left darker part of the track. This will put several dark splodges in the previously light part of the track. Do the opposite for the bottom-left detail, by placing a source point for the tool in the light top-right part of the track. You can see we are adding very noticeable blobs of the darker colours; these threaten to spoil our illusion.

With all but the heads of the group removed, now make lots of random clones, as before, from all different points of the path directly over the places where the different brightness blobs were. After eight or nine of these 'random clones', you will see the path detail start to even out and the dark and light areas of the path will merge to form one perfect path. Now we just have the group's upper torsos to contend with.

Now we have to remove the tops of the people's heads. Because we worked so hard to get the path to look right, we don't want to risk swapping any detail from the playground over to the path. With this in mind, select a small, harder-

edge brush from the clone-stamp brush selector at the top of the screen. We want to carefully follow the line of the edge of the playground. To make this work, you must set a source point for the rubber-stamp tool directly on this line, and then interpolate and draw diagonally downwards to create a curved line. This will take several settings and re-settings of the tool; persevere and the results will come. Thankfully, when zoomed in the detail in the playground is actually very easy to cover once the boundary has been drawn. Simply take some random samples from the relevant sides of the group's upper torsos and you're there. The final small group of interfering people on the far left is a doddle. Go for it!

Now for the real fun: one massive subject in the middle of a scene with a complex background to attempt to interpolate.

The best way to tackle something this complex is to use a large soft brush at first and only clone areas that have no direct contours behind them, such as the bottom-right area with gravel on the track, the upper-central torso that has largely just green grass behind it and the absolute top of the head. Do a very rough clone out of these areas. With a little luck, you should get something like this:

For the remaining part, it's all down to personal technique. I mix a combination of mid-sized soft brushes for areas within the grabs, being careful to match up the similarly coloured grasses. For harder lines like the top of the path behind our subject's head, I swap to smaller, harder-edge brushes and spend time ensuring the contour of the path follows through naturally. In the end the result is this:

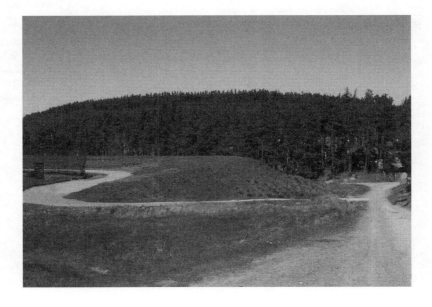

Perfection! Did you do it? If you've managed this, then you are certainly going to be able to remove anything from almost any picture. I hope you enjoy the feeling of power you will get from playing God with your digital photos in the future!

how to fix damaged photos

Fixing damaged photographs, such as old photographs or ones which have had part of an image scraped off, is equally as easy. Of course, digital photos never get damaged but you may have old 'traditional' pictures laying around or, indeed, digital photographs you have printed out that have been damaged. If this is the case, you will need to scan them into your computer. In Photoshop you can achieve this by clicking on the File menu at the top of the screen, clicking 'import' and then selecting your scanner. All scanners are automatically recognised by Photoshop if they are installed correctly, which is very handy. Make sure you scan at as high a resolution as possible. The higher the resolution you scan at, the less loss of quality there will be when the image is scanned into your computer. As with digital photography, you should only ever scan at

the 'natural' resolution of your scanner, not the interpolated 'digital' resolution, which is similar to the weigh-off between optical zoom and digital zoom.

For this exercise, open 'image 4.jpg' from the 'Removing Unwanted Elements' folder. It is an old black and white picture that has several blemishes on it. Thankfully, fixing pictures is a lot easier and less time-consuming than the techniques employed in the previous exercise. You can see there are several white blemishes and a few clear lines where the image has been scratched and folded over the years. Most of these blemishes are one-click touch-ups, but some of the lines show the potential for problems.

First, you should get rid of the main easy-to-remove blemishes (circled) and also the scratch which is overlaying a black box. Any scratch or blemish that covers a solidly filled surface can be fixed in seconds. The scratches that cover the heavily patterned floor, however, are much harder and need a little extra trickery.

In the layers panel in the bottom right of the screen, click on the 'new layer' icon (the second from the right). A new layer will appear called 'layer 2'. Make sure you are clicked on the initial photo layer and it is highlighted blue. Now, using the rubber-stamp tool, use the smallest brush size possible and set the source point to a fraction to the left of the main left-hand side scratch. Now, in the layers panel, click on 'layer 2' so it turns blue and becomes active. We can now use the first layer as the source and clone directly on to the second layer. This means

we will never damage the underlying image yet will be able to clone over the scratches. And if we make a mistake or the image starts to look unnatural, we simply 'Ctrl + Z' to undo or use the erase tool (press 'E'). Keep cloning until you have a perfect match for the scratches and you have a restored photograph! Don't forget that every time you need to set a new source point, you have to click on the underlying image in the layers panel for the source to be set.

how to colour-correct your images using levels and colour balance

Colour correction happens in most commercial images. In the first half of the book, you probably realised very quickly how useful it is to be able to change your white balance and play with different exposure variations in order to change the general brightness and tone of your image. Of course, whatever you photograph needs to be as good as possible in the first place, and as long as you have a good range of tonal values, shadows and highlights, it is possible to play with any element of the image and modify its colour. Even though colour correction is one of the most subtle of the digital-imagery manipulation arts, it is one of the most important and any of your images can be enhanced rapidly with a little applied knowledge.

Equally, though, changing colour in your images can also be a lot of fun: removing red-eye or excess colour spill is very handy.

Earlier, I told you how digital images are composed out of red, green and blue channels which contain brightness information for each pixel. Now we are going to start using these channels to manipulate the appearance of your images.

Photoshop, and most other mainstream image-editing packages, are aware of how important it is to be able to colour-correct and have many features that allow you to change any aspect of your imagery.

Open Photoshop and go to the File menu. Select 'open' and navigate to the 'Colour Correction' folder on the CD-ROM. Open 'image 1.jpg'. You can see that the group portrait is very heavy on the green, with the subjects sitting on grass under a canopy of trees on a sunny day. There is clearly a lot of colour overspill shown in this image, which needs to be removed in order to get a better-rounded picture. Go to the Image menu at the top of the screen and select 'adjust the levels'. You will see a histogram appear, which has a graph with various heights representing the various values of colours in the photograph.

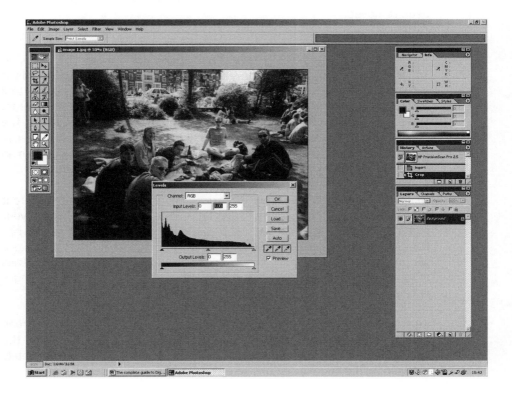

At the moment you are looking at the histogram for all the channels: red, green and blue combined. We want to focus on the 'green' channel for this example. From the dropdown box, select 'green'. You will see that towards the darker end of the spectrum, to the left of the graph, the peaks are quite high. This means that there are a lot of dark greens within the image. As we progress towards the right, the values lower, but it is clear that there is green everywhere. We want to try and lessen the amount of dark greens within the image and decrease the amount of light greens as well (the light greens would be represented by the green overspill from the reflections of the leaves and the grass, and also light skin tones and clothing).

At the bottom of the histogram chart, you can see three small upward-facing arrows. These are control handles for the graph. The left one is black and represents dark tones or shadows; the central arrow, which is grey, represents mid-tones; and the light arrow on the right is image highlights. To reduce the amount of dark and light greens in the picture, move the shadows arrow to give an input level of 24, the mid-tones arrow to give 0.92 and move the highlights arrow very slightly so its input value reads 252. Suddenly, you can see the image looks a lot richer and a lot of the excess green has now been removed.

Click 'OK' and the changes that you made to the image become live.

You may have noticed the 'auto levels' command when we went to the Adjust sub-menu from the top Image menu. This is normally an incredibly useful tool and operates by looking at the peaks and troughs within the levels histogram and equalising uneven juts as well as making the lightest colour lighter, the darkest colour darker and evening out all other colours in between. However, it doesn't take into consideration any excess of colour which may exist in an image, so for this example it wouldn't have been particularly useful.

Of course, there are many times when you want to play around with different variations of colour corrections, but it's quite a hassle repeatedly copying your picture on screen and manually applying different corrections so you can compare different results and select the best. Fortunately, Photoshop has a 'variations' command, which simply takes your initial image, creates a series of thumbnails (smaller images) and then allows you to apply various changes in colour to the highlights, mid-tones and shadows.

Remove the picture we just colour-corrected and reopen the initial over-green image. Go back to the Image menu, then the Adjust sub-menu and at the bottom of the list of options, click on 'variations'. Your screen will be completely hijacked by the huge Variations screen.

You can see the original in the top left-hand corner of the screen. Mid-tones are initially selected and you will see a slider bar reading 'fine' and 'coarse', with a control handle in between. The initial setting tends to add too much of any of the colours, so I recommend sliding the control handle towards 'fine' by one notch, allowing you to alter the colour correction more subtly. In the main area of the screen, an image saying 'current pick' is labelled. This indicates the present state of the current colour correction that is being applied. If you look around the outside of this image, all the other images are actually buttons. If you look closely, each of the image buttons has a slightly modified colour, with more yellow having slightly more overall yellow, more red slightly more red and so on. This can give you an initial idea about the direction in which you might want to start trying to colour-correct.

The image buttons around the centre operate on the colour-wheel concept. If you press the 'more red' button, the button on the opposite side of the wheel, 'more cyan', will add more cyan and cancel out the corresponding addition of red. If you click something too many times, you can click the 'original image' button in the top left of the screen and all images will revert to the initial colour set-up. We know there is too much green in this image, so let's try the opposite side of the colour wheel and click 'more magenta'. Magenta is a variation of purple. After two clicks, the picture in the centre looks a lot better balanced.

The 'more magenta' button actually shows the image as it would look were you to press the 'more magenta' button one more time. The image is also a little dark for my liking, so clicking the 'lighter' button on the right-hand side of the screen is extremely useful. Compare the original and current picture at the top of the screen: the difference is massive. Now for the *coup de grâce*.

We have been altering the mid-tones of the image. The mid-tones represent all the values that aren't extremely dark or extremely light, and thus these values have a large overall effect on your picture, without adding any unnatural values (such as adding more magenta to shadows – have you ever seen a purple shadow? Didn't think so!). You will see there is a checked box called 'show clipping'. This box means that any areas of the picture that would be unnaturally saturated with the new colours you are adding are highlighted. Think of 'show clipping' as a warning not to add any more of a colour. I recommend you always leave this option turned on. Click on 'saturation'.

If you don't see any of the clipping option's fuzzy ghosting, then the image is correctly saturated and you can click 'OK', returning to the main Photoshop workspace with a perfectly colour-corrected image.

For anyone more technically inclined, colours are equalled out by swapping the primary colours of light with the secondary colours of light. Imagine you have your red, green and blue (RGB). When you mix red and green together, you get yellow. Thus when you have too much blue in an image, by increasing the amount of yellow you are actually increasing the bias of red and green in favour of the blue, thus equalising the amount of blue in the image. This is quite a tricky concept to get your head around, so if you understand it, well done!

Although the individual level's command is extremely accurate and powerful, a lot of people don't want to get involved with fiddling with histograms and sliding different values in different channels. This 'variations' command is a perfect alternative for those who want a good deal of control with minimal brain strain.

Another method of colour correcting, which operates in a similar way but doesn't let you see many variations next to each other at the same time, is to use the colour-balance tool.

Open the initial over-green image again and go to the Image menu, select 'adjust' and 'colour balance'.

Again, we have the opposite sides of a colour wheel balancing each other out and enabling you very easily and accurately to change the subtle balance of shades of colour within an image. Move the magenta-green control handle to the left, until a value of about -45 is displayed in the centre. To make the picture a little warmer, add a subtle red hue. Shift the red control handle to the right to give +20. To me, the blue-yellow value of the picture looks correct for a bright, sunny day, but all colour correction is subjective to an extent.

Now click on 'shadows'. When we increased the warmth of the picture by increasing red mid-tones, we also altered parts of the darker shadows near the bushes. We can shift the colour balance away from red in the darkest areas of the picture by shifting the red control handle back to -20, but the mid-tones we changed around our subjects remain. The highlights in the picture have taken well to the changes made to the mid-tones, and don't need extra attention.

Because you can preview all the changes you make on screen on the fly, you can very accurately colour-correct your photographs. The only drawback with this level of accuracy is that you can't compare the image to the original picture unless you open separate instances of the same image. I generally prefer to use the 'variations' command as a rough guide to start with and then alter the images more accurately when everything is pretty much balanced, with the colour-balance tool.

marquees and masks

Mattes and *masks* are methods for selecting very specific parts of an image and doing things with just the selection you have chosen. This can be from just colour correcting a very small part of an image to cutting an entire person out of a photograph, which we will do in the image-compositing section. To be an adept image manipulator, you need to be able to use many methods. Fortunately all image-editing packages have a range methods for creating masks and mattes: let's have a look at some.

A quick point to note: we aren't going to go into massive detail about each of the ways to select portions of an image because the later tutorials use and explain the relevant methods and discuss when you will need to employ them. Also, they're pretty dull and don't directly relate to image manipulation in relation to digital photography.

Open the 'image 1.jpg' from the 'mattes and masks' section folder. We are going to use different methods of separating items from a background so you will be able to modify, colour-correct or remap to the specific area you have selected.

First, press 'Z' to access the zoom tool and draw a box around the head of the guy with the shades on.

This is actually me (a few years ago when I was slimmer...)! I had to get a shot of me somewhere in the book! We want to decapitate me: your way of getting your own back for all this work I'm forcing you to do! Now press 'Shift + L' to select the lasso tool. When you have 'Shift' pressed and continue to hold 'L' you will cycle through the entire group of lasso tools, which are one of the best, most accurate and easiest ways to separate (at least) small subjects from their backgrounds.

Click at the bottom-left base of my neck and draw around the perimeter of my head. Don't worry about accuracy at this stage, as we can add and subtract from the mask we create using the same tool. When you have traced all the way back to the point where you started, release the mouse button. You have made what is known as either a *mask* or a *selection*. I like *mask* as it sounds cooler...

Now zoom in even further and look at the edges of the mask. You will probably

find, unless you have a particularly steady hand, that the perimeter of the mask is uneven and not quite on the absolute outline. Given this, we need to add and take away small chunks of pixels so we can get a very tight fit. You will need to use the 'Ctrl' and 'Alt' ('Command' and 'Apple' on a Mac) to add and subtract from this mask. Have a go: press either key and draw a circle on the edge of the mask you created. Depending on which key you press, you will add a big bulge or take a big bite from the mask. Now, go around the edge of the mask and fine-tune the edge so we get a tight, perfect fit around my head. When you are happy with the tightness of your mask, go to the Edit menu and select 'copy' or use the keyboard shortcut 'Ctrl + C', then go to the Edit menu and select 'paste' or use 'Ctrl + V'. A copy of my head will be made on its own new layer. Click on the select arrow in the toolbar or press 'V' and move my disembodied head around the screen! Now make a few more copies of my head and place them over everybody else's heads in the picture.

Bit of a Being John Malkovich flashback there! Help!

Now we will use one of the other useful lasso-based tools, the magnetic lasso. With the last lasso, we had to trace around the image manually. It can be a bit time consuming making a tight mask in this way – adding and subtracting all the time – but the magnetic lasso removes this requirement, as it traces along clear lines of contrast, making for a quicker and easier job. Press 'Z' and zoom in to the other shade-wearing, spiky-haired dude's head. Press 'Shift + L' to cycle the lasso tools until the magnetic lasso is visible (it has a horseshoe-magnet picture next to it). Now, set the edge contrast to 10% (meaning the tool will automatically select areas of contrast within 10% of the originally selected lasso point), the width to 10 pixels (this is the area that the tool will scan for regions of contrast) and the frequency to 100, meaning it will scan 100 times per second, ensuring that no matter how fast your mouse moves, you can always get a good quality mask (you may need to change this depending on the speed of your computer). Now click on the edge where brown meets green and trace around the edge, watching as the tool makes any necessary automatic adjustments to the mask for you!

You will see that you have an almost perfect mask straight away when you close the mask by double clicking at the end. Now, we will colour-correct inside this area, without copying and pasting the head. Go to the Image menu, click

'adjust' then 'autolevels', then go to 'colour balance' from the same menu and increase the amount of red in the image. You will notice that all the changes we are now making only occur within the select mask: I'm sure you can instantly see the implications for your digital photography! If, at any point, you need to get rid of a mask, press 'Ctrl + D'. If you want to leave a mask active, but view the image without seeing the perimeter of the mask, you can press 'Ctrl + H' to hide and unhide the edges of the mask.

Marquees are more general tools, but still very useful. Close and reopen the image to quickly remove all the changes we made. Now press 'Shift + M' and cycle through the available marquee tools. You will see a rectangular marquee, a circular marquee and two marquees that allow you to select individual horizontal or vertical lines (although these are more useful for art purposes than digital photography).

Select the rectangular marquee and draw a box on the page. Now press 'V' for the select tool and you will find that you can move your selection around or colour-correct in the same way you did with lasso. You can also add and subtract from the marquee in the same way as before, giving you a great degree of control.

Now press 'Ctrl + D' to clear the mask and select the circular marquee tool. This time press 'Alt' before you start to draw and begin drawing from the centre of the image. You will see that by using the 'Alt' key in conjunction with the marquee tools, you can draw from the centre instead of from the edge. You can also use the 'Shift' key at this point in order to standardise the height and width of either a circular or a rectangular marquee. Using these tools together you can easily pick out simple frames or highly complex foreground images from their backgrounds: mastering these techniques is very useful in increasing your digital-manipulation prowess.

colour mapping and colour suppression

Some images suffer from too much of one colour. Images taken indoors, for example, in a room which has orange walls, an orange floor and an orange ceiling, are likely to spill orange light on to anything else. No matter how you fiddle with white balance or different brightness levels, there will still be an orange hue falling throughout the scene. Given this, changing the colour balance or suppressing certain colours so they are effectively removed from an image will allow you to balance the images correctly and fix even the weirdest of auras.

Colour mapping basically means colour swapping. You can take a colour within a photograph and a small sample and 'map' colour A (your selection) to colour B, the new colour. Changing lemons to limes or people to green aliens, for example, is a doddle with this function! Now, that gives me an idea...

Open Photoshop and go to the File menu at the top of the screen. Click 'open' and navigate to the 'Colour Mapping' folder. Open 'image 1.jpg'. You remember that horrible pink house (I have the misfortune to live near it – ugh!) from the section on 'How To Remove Unwanted Items In Pictures'? Why don't we give that house a much-needed makeover?

Go to the Image menu, click 'adjust' then and click on the 'replace colour' option. You will be presented with a new dialog box. Hover your cursor over the pink area in the centre of the front pink wall of the house. When you click your mouse, the tool takes a sample of the colour that your mouse was hovering over.

You should see a slider above a black and white representation of parts of the image called 'fuzziness' (nothing like a nice technical term!). What this means is that the computer doesn't see colours as we do; all it has is those three channels of greyscale information coming from the red, green and blue channels. All it knows is a numerical value for whatever colour has been selected. If we modified only that colour, we would find that all the other minuscule variations of it wouldn't change and we would have a very weird-looking house! The fuzziness represents small variations in the shade of the chosen colour, and the higher the fuzziness, the more variations of the colour will change when we modify it. With this image, a fuzziness value of 50 and a lightness value of 60 gives the back-facing wall a perfect whitewashed tone.

Now click 'OK' for the changes to take effect. Now we want to go back into the same tool, as we want to produce a cumulative effect while we move around the house, pink patch to pink patch. The reason we don't address the entire effect in one go is because when we increase the fuzziness, some of the colours

that are within that 'fuzziness range' are also present in other parts of the image which we don't want to change (for example, pink hues in bricks in the outer wall). So with the same feature re-entered, now select the cumulative pipette tool (the one that has a small plus by it) and select the three circled areas. This time, make sure the fuzziness value is set to 70, lightness at +44 and leave hue and saturation the same. Now our previously pink house should have turned completely white!

If when taking a digital photograph you are thinking of manipulating certain colours within the image in this way then, if possible, make sure to take the photograph in such a way that as few of the colours as possible appear elsewhere in the image. If there are colours elsewhere in the image, mask off the area you want to manipulate first to avoid spill.

The hue/saturation command works in a similar way, but instead of selecting a specific range of colours for you to modify, it will work on the entire image

or whichever area has been masked. Have a go at using it, although the 'replace colour' tool is much more powerful and you'll probably find it eminently more useful.

Selective colour is more powerful, but unless you have a minor brain extension, it is very difficult to be able to work out exactly what results you are going to get. However, with a little applied thought you can fine-tune any colorization in your image. Selective colour works on all primary and secondary tones within an image and offers you highlights, mid-tones and shadows for each of these colours. They can each be accessed from the dropdown box and for any of the three-tonal areas, you can modify any shades of the secondary and primary colours. While it does give absolute control, this excellent tool can be overwhelming and, because of the massive amount of potential variations, more than a little hit and miss. Give this tool a try when you are satisfied with your understanding of and ability to use all the other colour-correction tools.

altering the contrast, brightness and sharpness of an image

Some photographers go to great lengths to try to take pictures under lighting conditions which will provide high levels of contrast or show unusual levels of brightness. It's a shame they didn't learn about what digital image-editing technology can now do as changing contrast and altering brightness in specific areas of a picture is as easy as batting an eyelid and can create effects even stronger than those that such hardened photographers attempt to create.

Contrast occurs where a highlight meets a shadow, or where two distinct and different colours meet. Where these clash, the area contrasts and vivid lines and contours can be seen. Sometimes we want to increase levels of contrast to increase the power and dynamism of an image. Sometimes we need to reduce contrast in areas of a picture so the extra detail they create doesn't detract from the main subject. Either way, knowing how to alter the contrast is an essential skill.

There are several methods for altering the contrast of an image: the easiest is using the 'autocontrast' function. Open Photoshop and select 'open' from the File menu at the top of the screen. You should navigate to the 'Altering Contrast And Brightness' folder on the CD-ROM and open 'image 1.jpg'. This image, taken at a stately home, clearly has very poor levels of contrast. There are very dark areas within the picture as well as some pure white highlights created by natural light. Neither the dark looks dark enough, nor the white looks white enough. Open the Image menu and select 'adjust', then 'autocontrast'. Autocontrast is a tool I use on a lot of the images that

I take. Photoshop looks at the pixels closest to white contained within the image and also the darkest. It then remaps the brightness of the lightest white to pure white and the darkest dark to black. All the other hues in the middle are then stretched out across everything in between and their brightness increased or decreased accordingly. This creates much more vivid images and allows a one-click option that can be applied to any image that needs a little more definition.

By applying autocontrast then autolevels, you get a well-defined picture with even balance across its spectrum of colours.

Sometimes your photographs, for whatever reason, simply aren't bright enough. With this in mind, being able to raise illumination is a very useful skill. However, there are several different techniques available for different circumstances.

Open Photoshop and open 'image 2.jpg' from this chapter's tutorial folder. You'll see a rather under-exposed orange ball. We need to brighten the image. Easy! Click on the Image menu, then 'adjust' and select 'brightness/contrast'. You'll get the Effect dialog box with two simple sliders: one for brightness and one for contrast.

Increase the brightness level to +45 and we are approaching the correct level of brightness, However, the brightness levels are being raised across the entire image, making it look very flat and reducing the perception of detail across the

board, which is no good. Fortunately, by increasing the level of contrast, you can add some much-needed detail and also increase the perception of colour in the subject of the picture. Reduce brightness to +25 and increase contrast to +33 and suddenly the overall picture is not just a lot brighter, it is also a lot more vivid, now holding together perfectly as an image.

The brightness/contrast effect is a very effective way to improve images that are too dark overall, but it does have its limitations, which is where the curves control comes in, plunging us back into the realms of the graph.

The curves controller is actually part colour-correction utility and part brightness control. For people learning digital manipulation, the more extreme ins and outs of the tool are overly complicated and not sufficiently useful to warrant detailed explanation in this book. However, as a brightness controller and general level changer, it is simply second to none.

You'll see the curves dialog box has two brightness bars, going from left to right and up and down. There's a 45-degree line shooting upwards. This gives the levels in the active channel as they are presently mapped, as shown over the page.

This means that white on the horizontal bar is equal to white on the vertical bar. Reading along the brightness bar to somewhere in the middle shows not where

grey values are in the image, but where the mid-tones are in each of the channels. By clicking on the middle of the diagonal line, you place a control point on the line that you can then drag outwards or inwards. When you move one of these points, the line will 'curve', hence the name of the tool. If you move the line to the left and up slightly, you'll see the picture getting lighter, but the darkest shadows will not appear to be changing. Why is this? You will see that the control point previously represented the mid-tonal level of the picture. This point has now been moved upwards and by drawing an imaginary horizontal line, it has moved towards a lighter level on the vertical bar. What has happened is the mid-tones have been remapped to this higher, lighter level. If you follow the 'curve' you will see that all the dark values have increased, but proportionately less than the mid-tones.

By selecting individual channels you can remap the brightness values of reds, greens and blues, giving you an incredible amount of control. This is further enhanced by the fact that you are not restricted to one control point on the curve, so you can remap anything. The reason the curves command works so well is that every change is slowly graduated: there are no harsh edges. In our example, above, we changed the mid-tones a lot, and the shadows increased in brightness by a correctly proportioned amount that related specifically to the mid-tonal values.

As you can see, the curves tool is fantastic for shifting overall brightness in an image, without blanching out any darker areas.

Getting used to what looks initially like a complex tool is a good idea, as before long it will become your standard tool of choice for changing an image's brightness.

other image-adjustment tools

You will have noticed that all the tools within the Image menu affect everything within your photograph. There are some stylistic tools within this menu as well, which are a good introduction to the filters we will be using later on to further enhance your digital imagery.

The four core image-adjustment tools are threshold, posterise, equalise and invert. They are all, other than invert, not desperately useful for a digital photographer, but can create some very cool variations on your photography, and the understanding of what they do will help you as your overall digital-manipulation skills increase.

You should navigate to the 'Altering Contrast And Brightness' folder on the CD-ROM and open 'image 1.jpg'. We will use this image to experiment with each of the four image controls.

threshold

Threshold is a weird one. It converts all pixels within an image to either black or white, depending on the pixels' brightness value. Go to Image, 'adjust' and 'threshold' and you will be presented with a histogram similar to the one used in the 'levels' colour-correction tool. The graph, from left to right, represents all possible brightness values within your picture. The left-hand side of this graph represents black, through to the right-hand side representing white. The lines in the histogram display how many of each level of brightness there are in the picture. This screenshot shows that there are a high number of dark shades, very few mid-range shades and a small but very distinct amount of bright shades.

Because of this heavily skewed distribution, setting the threshold control handle at the middle value of 128 over-displays the amount of dark hues within the image. A better bet for getting a good, even effect is to try to position the control handle so there is an even balance of lines to the left and right of it. For this image, a value of 94 displays a sufficient amount of detail, including the wallpaper pattern. Click 'OK'.

Of course, the threshold tool makes everything pixelated. It doesn't add any graduation between the light and the dark pixels, which is all a bit ugh! Click the Filters menu at the top of the screen. Click 'blur', then select 'gaussian blur'. Set the blur value to a radius of 1.5 pixels. This is just enough to soften all the areas of contrast on the page and give a nice effect. You can now also see how flexible Photoshop is when you are able to combine more than one image effect; this is where the clever application of effects and filters on your digital photographs can turn photography into digital art! Now we have some new toys to play with, let's check out the other image-adjustment tools and see if we can make some more cool effects.

posterise

The *posterise* effect is threshold with knobs on: big, bold, brass knobs! Whereas threshold changes all pixels within an image to black and white, depending on the brightness of the pixels, posterise allows you to create banded effects which, when combined with other filters, like the earlier threshold example, allows you to create very fast, but high-impact artistic effects.

Open 'image 1.jpg' again and go to the Image menu. Click on 'adjust', then 'posterise'. The image will instantly become pixelated and you will see that many of the in-between shades that make up detail in a picture have been removed. Increasing the colour values in the tools control box offers varying degrees of detail. You will also see that this tool does not have the same degree of control over the outcome that threshold has.

Given this, the posterise function should generally be used only as an artistic effect. The following tried and tested artistic technique using posterise makes our subject look like an illustrated image combined with a background photograph.

Reopen the initial image and go to Image, 'adjust' and 'autocontrast'. To make this effect work we need nice sharp edges. Now we must copy the image to a new layer by clicking on the layer in the layers panel at the bottom right of the screen (if this panel isn't showing, click on the 'layers tab' to make it active). Now drag the layer by clicking on the layer, holding down your mouse button and dragging the cursor over the second-from-right icon. You will see the initial image cloned on a new layer. Click on this new layer (the one at the top of the stack) so that it turns blue and becomes the 'active' layer. Now click on the Filter menu at the top of the screen, click 'other' and select 'high-pass'. This is a very useful filter which, depending on the selected ratio, converts colours in an image to greys and darkens areas of highlight and shadow, creating strong contrasts. Select a radius of 4.5 pixels: this is the radius of influence upon which the filter works.

Go to the Image menu and select 'adjust' and 'posterise'. I recommend keeping the initial setting of four levels, although the filter actually appears to work rather randomly – try typing in five and see what happens, then six – no rhyme or reason whatsoever! And now for your first foray into blending modes. We are now going to combine our strange-looking, semi-grey, slightly colour-speckled, overlaying

image with the image underneath to create a new artistic effect. In the layers panel, you will notice a dropdown menu which says Normal. This is the blending modes box. Blending modes are mathematical equations that tell the image layer you are working on to look at the colour values of all the pixels directly below and perform a numeric operation on them. Remember that the red, green and blue values of pixels are actually just three sets of numbers between 0 and 255 (giving 256 overall possible values). Depending on the blending mode, the two sets of numeric values for the pixels may be added, subtracted, multiplied, divided or have any number of different functions applied to give a blend (hence blending mode). Of course, RGB - 20*3 isn't particularly catchy or memorable, so this dropdown box contains some easy-to-remember names for the equations that represent what the mathematical functions look like to our human eyes. For this example, we want to select hard-light. This blending mode makes the image on top project on to the underlying image (in this case, the same image with different colour values), as if it were a transparent film and a very bright, harsh light is being shone through it.

After hard-light has been selected, you should click on 'opacity' and change the value of the hard-light layer to 80%. You can now see the top image blending with the richly coloured image below to give a bright, highlighted image with certain cartoon-like characteristics. Now, go to the Filter menu, click 'blur', then

'gaussian blur' and set the radius to one pixel to smooth out the over-pixelation (although this is an artistic style in itself!) and press 'Ctrl + Shift +E' to flatten the image into one coherent whole.

equalise

Ah, the black sheep of the bunch. This filter does a job very similar to autolevels, yet the end result on your screen is, frankly, horrendous. Unlike the other three image-adjustment tools, which are generally useful for the creation of artistic effects, this tries to do everything and succeeds in making any image bland.

If you remember that autolevels works by taking the lightest colour in an image and making it white, and the darkest colour in an image and making it black, and spreading out all the other values in between, well that's exactly what this effect does. The only problem is that it doesn't scan the entire image: it scans individual channels. Remember that all colour information is based on three separate RGB values, all of which span from complete white to complete black, so if the lightest tone was in the blue channel and there was a light value of, say, 220, this value would be boosted to pure white, which is 255. Because this works in conjunction with the other channels, you won't actually see white – just the equivalent of more light in the blue channels. The same happens for

the dark colours, and again, all hues in between are spread out. Of course, the unfortunate downside is that your previous image simply becomes lifeless and flat, but this can be useful to know if you want to enhance a photograph by making it look particularly bleak.

invert

The last of the main image-adjustment filters is a whole lot of fun, but also highly practical. It simply inverts all selected segments of an image. White becomes black and black becomes white. This can make for some good-looking images: night scenes with stars become particularly interesting when this is applied. Indeed, this effect is used so often by imaging professionals that the keyboard shortcut 'Ctrl + I' has been assigned to it. What makes it so useful, apart from making pictures look a bit weird? Well, remember the name of the package Photoshop. Photoshop was around long before the boom in digital photography, and was mainly created for retouching and working with photographs. Now, at the risk of selling my soul to the devil, the image we have

been using in this chapter wasn't actually digital, but came from a good-old analogue camera that created a negative from photographic film. Many scanning packages come with negative scanners, which allow you to take a raw negative into programs like Photoshop. With a negative, simply apply the invert command and you get the complete inverse, which is a full, correctly coloured picture!

Open 'image 2.jpg' from the CD-ROM, press 'Ctrl + I' to invert the negative, and *voilà* – a positive!

This enables you to scan in any old analogue negatives that you might have lying around and immediately convert them to a digital format, which you can play around with to your heart's content.

These four image-adjustment filters have their merits in helping you create artistic styles and are a good introduction to the artistic filters we will be using later in the book. With them you can boost your creativity to massive new heights!

image compositing

You may have heard of 'compositing' in relation to motion pictures and television graphics, but not in terms of static photographic imagery. A *composite* is an image which has part of another image merged with it to create a full new

image. The new image is known as a composite. In terms of movies, film is taken and maybe a 3D model, such as a spaceship, will be 'composited' into the scene. The finished scene is the composite. Strictly speaking, anything added from one image to another is a composite, but generally taking a person, a model, a car or some other item and giving it a new home in a new image is generally considered to be a composited image. There are many ways to get a natural-looking composite, one that people wouldn't know came from two (or more) separate sources.

Navigate to the 'image 1.jpg' and 'image 2 .jpg' files in the 'Image Compositing' folder of the CD-ROM and open them. One is a picture of a young man sitting in a restaurant; the second a brightly lit landscape. We are going to create a composite of the two by carefully cutting the man out of his background, altering his colour balance, brightness, highlights and shadows, and blending him in with the background to make a new composited image.

Firstly, we need to cut him out. There are many tools for doing this (described later in 'Alpha Channels, Mattes And Masks'). We are going to create a mask using the pen tools, which allow you to make a mask based on 'Bézier curves'. Bézier curves are mathematical points connected by lines, which form the edge of the masks and can be subtly altered by handles. These handles give you a very high level of control over the shape of the curves, and thus the overall shape of the mask.

Select the pen tool on the left-hand side of the screen. (If you hold down the mouse button for a second over the top of the tool, you can see the other available pen options, but we will only need the standard tool). You can also press 'P' to rapidly access this tool. Zoom into the bottom right-hand side of the picture, where the man's coat first starts rising. Click on the bottom-most point of this coat, from where we shall start creating the mask. Now click at the next natural point, which is before his coat begins another curve. You will see that a straight line is created between the two points. Don't worry that the line is straight. When creating a Bézier mask it is common practice to create a very rough, linear, straight-edged mask around the perimeter of the item that you want to cut out.

Continue to make linear points around the edge of the entire person, attempting to keep as close as possible to the edge of the outline without making 20,000 individual Bézier points: I have got away with just 30. Because the hair is jutting out at crazy angles and because we need to take his hair into the new composite to make the image look 'real', we need to avoid cutting any detail around his head, so make your Bézier points extend past the outer reaches of his hair, as shown at the top of the next page.

Now the fun starts. To modify the Bézier points and transform the straight lines into contour-hugging curves, you need to combine your mouse with the

'Ctrl' and 'Alt' keys. By pressing 'Alt' when you are over one of the curve points you get an inverted 'V', which allows you to click and drag on one of the points. After this you will see control handles appear. As these appear, you will also notice that the previously straight lines on either side of the control points begin to curve. The moment you see these control handles, you can stop pressing the 'Alt' key and release the left mouse button. Now, press the 'Ctrl' key and the cursor will change to a different type of arrow. This arrow is used to drag the handles of the control points which we just made appear from the centre of the Bézier point. Sounds a bit complex, but it isn't! Drag one of the control points and see how you are modifying the shape of the curve on either side of the Bézier point. You have now converted straight lines to Bézier curves. You will see that with the 'Ctrl' key pressed, you can move both sides of the handle like a see-saw. This can be annoying when you only want one side of the curve to move. To make this happen, you should press the 'Alt' key again. You will get the same inverted 'V' as before. Click on one of the control handles and, with the inverted 'V' held down, you will see that only the side of the Bézier point which you are moving modifies the curve.

With these basic tools, you can create a perimeter that hugs the outside of any object. The idea is that we will convert this mathematical system of lines

and curves into a mask, which we can then use to cut out our foreground item. We can then deploy this over the background image in our other photograph.

The other useful part of the pen tool is that it enables you to add or subtract Bézier points. By hovering over an existing Bézier point, you will see a small 'minus' symbol appear near the pen. Click a point, and it will be removed. If you move the pen tool (with no extra 'Alt' or 'Ctrl' keys pressed) over any part of the lines created, you will see a small 'plus' symbol appear near the pen. This allows you to add extra Bézier points from which you can apply extra detail and make more complex modifications.

Well, those are the tools, so go and make a figure-hugging perimeter. The pen tool is the single most useful tool for being able to cut items out from a background accurately and quickly. You should get used to using the 'Alt' and 'Ctrl' keys until it is second nature.

You can see that the Bézier curves are tightly hugging the man's jacket, with a large gap around his head. We will tackle his complex hair pattern separately.

On the right-hand side of the screen are many docked panels containing various other options. In the bottom right is one called 'layers', with some tabs (circled). Click the 'paths' tab, and you'll see a small outline which looks like the path you've created. (A path is the name used to refer to a connected sequence of Bézier

curves.) Put your mouse over the 'work path' in the panel. Your cursor will become a small hand with a pointing finger. Press the 'Ctrl' key while hovering over the work path, and you'll see a small square with a mini outline appear. Click your left mouse button and you'll see the work path converted to a mask: the same as the ones discussed in the previous section. Press 'Ctrl + X' to cut out the man from his background. You can also achieve this by mouse clicking on the Edit menu at the top of the screen and selecting 'cut'. Now press 'Ctrl + Delete'. The background will turn white. If it turns any other colour, press 'X', then 'D' and then 'Ctrl + Delete' again, and it will definitely turn white. Now press 'Ctrl + V' to paste the man back on to this white background. This technique is called 'clean plating'. We are putting the cut-out man back onto a clean plate of white so we can easily distinguish any discrepancies with any of the detail around him. In the top right-hand pane, there are two tabbed panels labelled 'info' and 'navigator'. Ensure that 'navigator' is turned on and that the zoom scale is set to 100%. This ensures that the man is at the correct size on the display so that there will be no scaled pixels that could distort the part of the process which must be the most accurate.

Now that we have clean-plated our cut-out, I can already see some very small areas of inaccuracy we want to remove. Zoom in to anything which stands out as being surplus to our subject; I have inadvertently taken some blue background from his left arm in the previous image. Zoom in (press 'Z') to the area of the discrepancy and create another new work path by selecting the pen tool and creating some new Bézier curves as before. Go around any suspect-looking edges and remove these unwanted intrusions.

After

Before

Now for the hair! Obviously, we could make a very complex mask around the edge of each and every jutting-out hair, but this would (1) take for ever and (2) not be that accurate, as the curves are ultimately better for smoother surfaces.

We need to be able to completely isolate the edges of the hair and convert these edges to a mask in order to cut out his head, as we did for his body. We are going to make a copy of our subject and perform a function on the copy that will allow us to make a perfect mask then use this mask directly on our subject. In the bottom right-hand panel, click on the 'layers' tab, as shown overleaf. Drag the layer that contains the cut-out man to the icon in the second-to-bottom- right corner. Click on the eyeball icon on the initial layer, so only the copy is visible.

In the Filter menu at the top of the screen, navigate to 'other' and select 'high pass'. High pass is a filter that looks at different brightness values and converts them to greys with a harsh edge. This harsh edge is going to provide us with a useful, stark background so we can pick out individual strands of hair. When you select the filter you will see the colour of the overall image change dramatically. We need to set the value of the high pass to five pixels. The picture will turn mainly grey and the edges around the central grey area will turn much darker, allowing you to differentiate easily between the

foreground element (person) we want to remove from the background. Now go to the Image menu at the top of the screen and go to 'adjust'. You will see a menu with more options. Select 'brightness contrast'. When a new dialog box appears, change contrast to +40. You will now see further enhanced edges.

Press 'Q'. You are now in a completely different mode of Photoshop: the quick-mask mode. This is intended for image editors who want to create very quick masks, but can also be used for creating very accurate masks in highly detailed pictures – perfect for what we need. Zoom in around his hair, starting with an extreme close-up of the entire top half of his head. Press 'B' and select a brush with a hard edge. I am using a 21-pixel brush. Draw 'inside' his head, but leave a large gap between the edge of your painting and where his hair begins. You will see that you are painting a semi-opaque red! What's going on? Well, in the quick-mask mode, anything you paint in black (the default brush colour) is shown as red. Back in the normal mode, any of this transparent red region is being converted into a mask. We are going to very delicately paint inside his hairs, so that when we return to normal mode we have a perfect and highly detailed mask to cut out the complex pattern of his hair and place it perfectly into our composited background. Take some time over this, using a very small brush for the finer areas, and fill in everything down to below his ears.

When you have a tight fit and have selected all his jutting outcrops of hair, press 'Q' again and you will see you have a near-perfect mask around his head. Of course, we could do without him being grey as we will need to reverse the 'high pass' filter to define our edges. We also need to incorporate the areas we previously cut out to give us our final mask. To do this, we need to invert the mask. So instead of the area inside his head being selected, the area outside the mask is selected so the obtrusive background can be easily removed. Press 'Ctrl + Shift + I' to invert the mask. Now zoom out fully and you will see that everything but the area we selected with the quick-mask mode is selected. Press 'M' to select the marquee-mask tool, as described in the previous section. Press 'Alt' to make the mask tool subtract rather than add and draw a box straight across the point just below his ears. This will leave the mask looking like the image at the top of the next page.

Now, click on the eyeball icon in the layers panel for the grey layer to make it invisible. Click in the same place on the layer below to turn on the eyeball and make the non-grey man visible. The mask we created is still in place. Now for the magic! Press 'delete', and everything within the mask area will disappear, leaving (depending on how accurately you quick-masked his hair) a perfectly cut-out person, complete with complex hair. Now for the real fun... In the layers panel, click on the layer and keep your mouse button held down. Drag this layer on to the background photo, which should still be open. This transfers the layer from one image into another image. This in itself is a composite,

but you'd rather make a believable composite than a half-hearted effort, wouldn't you?

You can close the image we were just working on by clicking on the 'X' in the image's top right-hand corner.

On our new image, position the man at the bottom of the frame on the screen. He doesn't look right. This is because the lighting in the picture he was previously in consisted of different shading, different highlights and different overall ambient colour. Fortunately, using some of our colour-modification skills explained earlier, we can blend him in with his new background immediately.

With the cut-out's layer still active, go to the Image menu at the top of the screen, select 'adjust' and 'autolevels'. This will take the brightness levels of the overall picture and remap those presently on the active layer. Immediately, you will see the man looks a little sharper, bright and vivid, very much like the background image. Even the previous light highlights around the back left (our right) of his hair have been tinged a slight blue to match the highlights being cast by the deep blue sky. The greens that were previously more matt now more evenly mimic the rich green of the forest in the background. Sneaky stuff! That is how you composite an image, although you will often be in a

situation where the automatic level adjustment doesn't quite appear correct. Under these circumstances, you should alter curves and levels manually to get the perfect balance across the entire image. People are among the hardest images to composite; anything that has harder, smoother lines is generally a lot easier.

creating a photo montage

Now we have ventured into the quick-mask mode a whole host of creative options have opened up for you. One of the most common collections of photographs in a household is a photo montage: a cut-out selection of photographs within an A4- or A3-sized frame. Thanks to digital imagery techniques and editing software, you can now create a perfect montage on your computer and print it as one full sheet of A4 (or larger, if you have a larger printer). My personal favourite technique for creating such a montage is to seamlessly blend photographs together, so you get the main focal points of each image, and the 'wasted' parts of a picture surrounding your subject blending smoothly into the next image, creating a much nicer effect.

The quick-mask mode and the cunning use of some filters allows you to create this blended montage effect, although the actual technique is transferable to many other projects.

In Photoshop go to the File menu and create a new image, or press 'Ctrl + N'. When the dialog box pops up, you should enter the following dimensions: height 3300 pixels, width 2300 pixels, resolution 300 pixels per inch. This is equivalent to printing a full sheet of A4 on a standard photo-quality printer at a resolution good enough to look like a standard photograph. Because this is quite a high resolution, it's best to only use images in your own projects which are mega-pixel images (1280 X 960 and higher), otherwise you may find the images are too small to fill up the page.

This is the size you should make your own montages. If you want to copy the example using the same photos as I am in this section, navigate to 'creating a montage' on the CD-ROM and open the 'main image 1.psd' file, which contains a heap of images from which to create a montage. You will see that the images are all haphazardly placed. When creating a montage from your own images, simply open all the images you are thinking of using, then drag them into the montage frame by pressing 'V' to select the standard tool and clicking and holding down your left mouse button in the middle of the relevant photograph. Then drag it to the frame and release your finger from the mouse. All the images are placed on separate layers and you will see a long list of image names in the layers panel in the bottom right-hand corner of the screen.

Initially create a 'rough' montage by placing the images so they cover most of the A4-sized frame. You want the photos to overlap as we are going to fade the corners of each of the images away, creating a smooth blend and making for a great-looking gradient montage, looking something like the image at the top of the next page. If you find any white space in your own montages, you'll need more pictures!

A neat trick that is very useful when working with many images which may be hard to find in the 'layers' panel is to use the 'Ctrl' key and click on a layer in the layers panel. This will select the layer and put a mask around its edge, so you can instantly see where it is on the main screen and modify it.

The reason it is hard to find individual photos is because image-editing packages don't know what your images are called or how to differentiate between them, so they just call it 'layer one' or 'layer two'. It is useful in Photoshop to select a layer, right click on the layer in the layers panel and select 'layer properties'.

Here you can name the layer anything to make the layers easier to work with; rename as you see fit.

We will start by making all layers invisible except one, by clicking on the eyeball

next to the relevant layer in the layers panel. I have started with the bottom-left image as we are going to make the four corners of the montage first. These corner images will be the uppermost layer in the final composition.

Press 'Q' to enter quick-mask mode. Now press 'G' to select the gradient tool. This tool is represented in the toolbar on the left by a square which has black slowly fading to white on the right-hand side of its box. The gradient tool normally merges the selected foreground and background colour into each other. In the quick-mask mode, instead of drawing black to white (the default gradient colours) it will create a gradient of transparency to the semi-opaque red, as we saw in the previous section. Initially, to see how gradients are created, you should click your left mouse button when your cursor is positioned at the bottom of the screen. Hold down the button and drag your mouse all the way to the top of the screen. Let go of the mouse button and a gradient will be created that spans the entire length of the screen. You can control the line you draw to make sure it draws precisely upwards by holding down 'Shift' while you drag your mouse.

Press 'Ctrl + Z' to undo the last action. Now click and hold down your mouse button nearer the middle of the screen, drag the cursor upwards but this time only a short way. You'll see another gradient drawn, but this time much thinner, with the transition from transparent to red occurring in a very short space: between where you started your click and where you let go of the mouse button.

Press 'Ctrl + Z' to undo this again. Our target is to create a thin gradient around the edge of the photo image and to make the edges fade to transparent, thus enabling them to blend in with whatever image is placed underneath them. Click your mouse button about 75% of the distance from the top of the visible image. Drag the mouse and release at the top of the image (circled), ensuring you use 'Shift' to fix the gradient to a 90-degree angle.

Now go to the Filter menu at the top of the screen and select 'noise', then 'add noise'. Select 'gaussian', which is a type of distribution that spreads noise more evenly than the uniform setting, and set the level to 3.5%. Now press 'Q' again to get off the quick-mask mode. You will see that a selection has been made and that the bottom of the selection looks a little jagged. Now press 'delete'. You will see the top part, where the red from the quick-mask mode changed to transparent, disappear and the image now goes from transparent to solid. Perform this same operation all over again, but this time you want to place the gradient fill within quick-mask mode on to the right-hand side of the image.

Now perform the same operation on the remaining three corners, trying to make the gradient on the opposing corners' photos the same as their opposite numbers. When you have done this, it is a good idea to right click the relevant images and select 'layer properties', labelling the corners 'bottom left', 'bottom right' and so on, as we will have to reposition all the individual pictures near the end of the montage. In the 'layers' panel, you want to click on each of these four corners and drag them right to the top of the 'stack' of layers. This will place them higher up in an imaginary vertical plane, so all other images will be obscured by these corners when they are allowed to come back into view, as shown over the page.

Now you will see why we did the four corners first. Unhide the images that will go horizontally between the four corners and rename them 'middle top' and 'middle bottom'. In the layers palette (another word for panel), drag these

two middle images so they are positioned in the stack, just below the four corners. When you click on the relevant image, it automatically has its eyeball-visibility icon turned back on. You will see that these 'middle' images now look as though they are blended into the four corners: the montage is taking shape! At this point you should move the corners slightly so there is enough space for each of the main subjects in the photographs. Now, on the middle images, perform the same gradient fade in quick-mask mode, but this time only on the bottom and top edges respectively, so all parts of the strip look like one single gradient unit.

Now for the next layers. Work on the bottom layer first and unhide the relevant pictures. In my example, the two images on these second layers are large enough to fill the entire width of the montage. Make the images on the left lower in the layer stack than those on the right (again by clicking on the layer and dragging it up and down the layers panel). Make sure the right-hand image is overlapping the left one and perform the same gradient quick-mask deletion that we did for the other images. Notice that by planning the montage in this way, we are keeping the amount of blending (and ultimately effort on your part!) down to an absolute minimum; after all, if digital manipulation and editing are easy, you are more likely to do more on a regular basis! Rename the relevant pictures 'bottom 2nd left', 'bottom 2nd right' and so on.

For the central part of the picture, we want to do something a little bit special. Most montages look good with a dominant central image. Drag a suitable image that has not yet been used (I have a picture of some very drunk girls!) to the top of the layer stack. Now press 'Q' and enter the quick-mask mode. This time we want to create a radial gradient. Press 'F' in quick mask so you can access the gradient-fill tool. At the top of the screen are some options that allow you to select different kinds of gradient.

We have been using left-to-right linear gradient; we now want to select radial gradient. Do this and perform the same operation as before. Oh dear! The radial gradient is a lot less forgiving when it comes to accurate positioning than the linear gradient tool. Press 'Ctrl + Z' to undo the last delete. We'll have to be particularly sneaky in this case, otherwise our subjects' faces will be half eaten away! In the layer stack drag the central image to underneath both of the second-level layers we were just working on.

Hide the top and bottom layers and the central layer. Now click on one of the visible active layers in the 'layers' panel. Now go to the Layer menu at the top of the screen and click 'merge visible'. You can use the keyboard shortcut 'Shift + Ctrl + E' to perform this operation. The previously separate images are now combined as one. Rename the images 'combined images'. Now go back to quick-mask mode and perform the same radial gradient as we just

tried, exactly in the centre of the visible images. Now we will alter the gradient slightly with the gradient editor, allowing us to remove just enough space from the central plane of images to let the girls underneath shine through.

To open the gradient editor, click on the active gradient (circled). Then drag the control handle of the gradient to the right, compressing the gradient to the right-hand side.

Now perform the same delete operation again and this time you have a much tighter gradient around the edge of the circular mask. Make the central girl-image visible again and you can see them poking through to make a nice central feature for the overall piece.

Now we have just two gaps to fill in and the job's done, but I'll leave that in your now capable hands. This kind of montage will print out a photographic-quality A4 sheet completely covered with this blended montage. Refer to the 'Outlets For Digital Photography Distribution' section to make sure you get the best printing quality possible.

changing day into night

Or more accurately, day into dusk. We are all aware of the problems associated with taking photographs, digital or analogue, in poorly lit conditions. If there's a particular shot you want, well, you've just got to put up with the imposed limitations of Mother Nature... Or have you?

In a word, no. There is a simple technique that has been used for years in the television industry for making a piece of footage look as if it was taken much later in the day, but because the footage was shot in well-lit conditions, it has good levels of detail, colour and contrast to work with. The technique is directly transferable to digital photography and easily fools all but the sharpest eyes. It's also a very quick technique, which is never bad.

Open Photoshop and open the file 'image 1.jpg' from the 'Changing Day To Night' folder on the CD-ROM. You will see it is a moderately lit landscape taken early in the morning. Using two different techniques, we can make it look as if it was taken in the blazing midday sun, and then as dusk approaches in the evening.

Firstly, create a new layer by clicking on the circled icon in the layers panel.

Now press 'Shift + F' until the gradient-fill tool is selected and click on the active gradient at the top of the screen to open the gradient editor. Select the gradient second from the top left, foreground to transparent, which will give you a black gradient smoothly graduating down to complete transparency. You now want to move the starting point of the gradient to the right with the control handle.

Now click 'OK'. On the new layer we created, draw a gradient from the very top of the screen to the very bottom, using 'Shift' to lock the axis and ensure you are drawing in a straight line.

Don't worry – this isn't the final effect! You may need to undo this operation a few times until you get a good spread for the gradient. Now, in the layers panel, click on the dropdown box which says 'normal'. We are going to use

some blending-mode trickery to modify the time of day at which the picture seems to have been taken. First, select 'overlay'. Suddenly, the area of the gradient that was previously black has now overlaid the blue and made it far richer, with the blue becoming light – in conjunction with the gradient – in what looks like the horizon. Set the opacity to 80% to give a more subtle blend. This mimics the light you get between midday and 2pm on a bright, clear, sunny day, even though this image was taken on a not-so-bright morning.

Using the overlay mode with a black to transparent gradient increases the power of the blue in the sky and gently brightens other areas of detail within the image. Now it looks as though we took the picture at midday!

Now one step further: turning midday into dusk. Select the blending mode 'hard-light' and set the layers opacity level to 60%. Now the higher part of the gradient is making the sky look like night is rolling in from behind the photographer: day has (almost) turned to night!

Click on the bottom layer, which contains the photographic image, and click on 'autolevels'. The high levels of dark within the picture will now enable this tool to remap all the colours so they look as if they have had the corresponding decrease in darkness, finalising our day-to-night illusion! Simple, eh?

creating a vignette

A vignette is an old printing technique that fades the edges and sides of images to a darker background colour. This technique was popular in traditional analogue photography years ago, but can now be copied easily with image-editing packages. We are going to make a new digital photograph look like one of those old sepia-toned photographs from days gone by.

Open Photoshop. From the File menu, click 'open', navigate to the 'Creating A Vignette' folder on the CD-ROM, open the 'image 1.jpg' file. We want to create the kind of oval vignette that was popular in 'Wild West' times. Even though my model wasn't wearing suitable dress, the styles and techniques we use will make for a convincing vignette.

First, we need to give our model a plain background. For this we need to employ our pen-tool skills from the section on image-compositing. Select the pen tool by pressing 'P' or clicking on the tool on the left-hand controls bar. Begin creating rough points around the perimeter of our model, as shown at the top of the next page. I have used 26, but use as many as you feel comfortable with.

Now we need to fine-tune the edges of our path so we can remove the background from our model. As before, use a combination of the 'Shift' and 'Alt' keys in conjunction with the pen tool to enable you to drag the control

handles from each of the Bézier points along the Bézier curve. Spend a good amount of time making sure you get a very tight fit, but remember that this time, we are not so concerned about adding the high-pass filter and using the quick-mask mode to enable us to give a super-accurate mask profile of any stray hairs or other details. The operations we will shortly carry out with colour and ageing effects will erode the quality enough for this not to count.

Press 'Z' to access the zoom tool, press 'Alt' to zoom out by clicking in the centre of the picture until the image is back to 100%. Now in the bottom right-hand panel, click on the 'paths' tab. Where it says 'work path' hover your mouse. Now press 'Ctrl' and click your mouse to create a mask based on the work path you created. Press 'Ctrl + I' to invert the mask, meaning instead of our model being selected, we now have everything else selected. Now for a useful trick for softening the edges around a mask. Press 'Ctrl + Alt + D' to bring up the 'feather' dialog box. Feathering is the process of creating a small gradient ramp around the edge of a mask so that any painting, effects or deletions will blend the relevant command to the edge of the mask in a smooth gradient instead of a hard, pixelated edge. Enter the value 1 (higher values give a wider gradient ramp to any function, but for our purposes we will simply end up over-softening the edges of our model).

Now we want to fill in the background with grey. Click the box circled in the screenshot which will give you the 'select foreground colour' control. Make sure the checkbox for 'select web only colours' is not turned on and use the sliders to choose a mid-range grey colour.

With this grey selected, we want to use the 'fill foreground colour' option. Choose the Edit menu, click 'fill' and select the foreground colour. You can use the keyboard shortcut 'Alt + Delete'. You will now see the background replaced with our grey. Press 'Ctrl + D' to deselect the present mask. Now it's time to start making the picture appear as it would have back then. In the Image menu, click 'adjust' and select 'desaturate'. This converts any colour channels into one single greyscale channel, thus giving you a black and white image. It still isn't looking very 'old' though. Now click on the Filters menu, select 'noise' and 'add noise'. Set the radius to 2 and the distribution to 'gaussian'. Leave 'monochromatic' off and select 'OK'. You will now see that the image gets a slightly old-fashioned, 'noisy' feel, but we aren't there yet.

Click the 'layers' tab in the bottom right-hand screen corner panel and create a new layer by clicking on the 'new layer' button. Now, to activate it, click on the new layer that appears in the layers panel. We now want to select the gradient tool by pressing 'G'. With this tool selected, make sure that the linear gradient is the active gradient tool; you can change this by clicking on the relevant button at the top of the screen. Now we need to set the two gradient colours. You may remember the Gradient Creation menu from an earlier tutorial; click directly in the box at the top of the screen that has a black-to-white gradient in it and the gradient editor will become live. When you have the editor open, you should click at the two bottom colour-control handles to activate the colour picker. On the left-hand side, you should select a fairly vivid, but a slightly dirty orange. Mine has RGB values of 231, 207 and 0

respectively. On the right-hand colour-control handle, select a bright but flat yellow: try RGB values of 250, 250 and 145.

Now draw a gradient on to the new blank layer we created, and add the noise filter to this new gradient layer. This time, though, you want to change the value of the noise to 3.

Now for the first bit of sneakiness. With the new gradient layer still selected, click on the dropdown box that says 'normal', in the layers panel in the bottom right, and select 'soft light'. The soft-light blending mode makes anything underneath the layer appear as if it has a diffused light shining over it. Because of the colours we used in our gradient, we get an old-style sepia duotone

effect; phase one is complete! Now for the frame. Select the marquee mode by pressing 'M'. You can cycle through the other marquee options now by pressing 'Shift + M' again and again. Press it until you have the ellipse (circular) marquee option selected. Place your mouse cursor in the middle of the picture and press 'Alt'. Now when you click your mouse button and drag your mouse to make a marquee, you won't begin to draw the marquee from the corner, but your marquee will sprout from the centre of the image, allowing you to easily place a correctly proportioned oval around our model.

Create another new layer by clicking on the new layer icon in the bottom-right layers panel and press 'Ctrl + Alt + I' to invert our marquee selection. Press 'Ctrl + Alt + D' to open the feather tool (this can also be accessed from the Select menu). When the dialog box appears, type in 16 as the feather distance; this is the maximum permissible amount and is fortunately just the right size for what we have in mind. Now press 'D' so the default colours of black and white are replaced in the foreground and background colours boxes, and fill the active selection with the foreground colour by pressing 'Alt + Delete'. We now have our vignette, but it's the wrong shape. Activate the crop tool by pressing 'C' and draw a rectangular marquee around the vignette. Modify the shape of the crop with the control handles to make the vignette the correct size and shape, then press 'Enter'. On the gradient layer, press 'Ctrl + F' a few times to reapply the last filter we used ('add noise'). Continue with this until you are satisfied with the level of 'creak' present in your background, and there you go!

creating panoramic images

Panoramas are great fun. There are plenty of special cameras and lenses out there – digital ones too – designed purely to take panoramic images (vast, wide, extended landscape shots). Fortunately, anyone with a digital camera and this book can mock up beautiful panoramas without any special requirements – or even a tripod!

When you plan to take photos for use in a panorama, it is always good, if possible, to use a tripod, as it enables you to angle your camera perfectly and ensure that all horizontals are correct. However, you won't always be carrying a tripod or a monopod whenever you stumble across some particularly breathtaking scenery so, to get the necessary imagery, you should stand as centrally to the scene as possible and ensure that your camera remains permanently square to the landscape that you want to capture. Begin shooting from the top left-hand corner of the panorama and swivel your body, with the camera remaining on the same plane, so that each shot overlaps the last by at least 10% in each picture, as these overlapping areas are going to be blended into the last picture to create a smooth overall panorama. When you have reached the right-hand extent of your panorama, return to the left-hand extreme of your scene and begin a new 'layer' of images, ensuring that, again, there is overlap. This time also overlap with the images on the row above.

This step is only necessary if you are creating a large panorama; many panoramas can contain as little as two side-by-side images. As long as the same blending method is used, you can link together a near infinite amount of images as the correct image-editing techniques can be very forgiving, even if your camera work is a little 'off'.

Open Photoshop and go to 'open' in the File menu. Navigate to the 'creating panoramas' folder on the CD-ROM and open 'left 1.jpg' and 'right 1.jpg'. Depending on the size of your monitor, you may have to use zoom ('Z') and shrink the image size down to 50% so you can see both of the images on screen at the same time. Position left on the left and right on the right. Click on the left image to make it active and go to the Image menu. Select 'canvas size' and click on the middle left 'anchor' point to determine which way the overall size of the image will be extended.

Now type in 1,280 in the width text box. With this done, the size of the canvas (the name given to the working area of the image within Photoshop) will double and be coloured the same as the active background colour (in this case it should be white, but don't worry if it isn't). Now click on the 'right 1.jpg' image and press 'V', the shortcut to the standard select tool. Click and hold down

your mouse button in the middle of the 'right' image and drag it directly on to the image whose size we have already extended. Position it on the new white region.

Obviously, this doesn't look quite right. We need to position and remove certain elements of detail so that the image appears as a single extended panoramic image. In the layers panel in the bottom right of the screen, you will see a new layer has appeared. This layer holds the image we have just dragged on to our main image and is currently active. In the layers panel, you will see the layer has its opacity (how opaque or transparent it is) set to 100%. Change this value to 60%, allowing us to partially see through the image. This will enable us to roughly position the 'right' image in the right place. Drag the now partially transparent image so that the central, easily distinguishable clearing is laid roughly on top of the one in the other picture.

You will see that to get these images to fit as intended, you will have to lower the right-hand image considerably. This kind of discrepancy often occurs when you aren't shooting with a tripod, but you shouldn't worry at this stage. Try to match up some of the obvious detail, but don't worry when you see certain elements not fitting together perfectly (ie if the detail in the focus fits, the tree line doesn't and so on). Not a problem. Press 'Q' to enter quick-mask mode. We are going to cut out a graduated section of the overlapping

image, so any areas of incorrect detail flow seamlessly into each other, giving the impression of a perfect image.

Now we are in quick-mask mode, select the fill tool. We are going to use a technique similar to the one we used for creating a vignette: similar, but with some subtle differences to increase the level of quality. First, check the fill tool is set to 'linear fill'. We have a potential problem here as the fill tool always saves the last 'fill' that was active, and if you have been following this book through from start to finish, you will have the yellow/orange fill saved from creating a vignette. Not to worry! Simply click directly on the active fill state to open the gradient editor and select the 'black to white' preset, which is third along in the list of presets. Then click 'OK'.

Now draw a gradient, beginning a little inside where the overlap on the right image starts and finishing slightly to the right of where it ends. Ideally, follow the start and end places circled in the screenshot. You will see the opaque red of the quick mask again, as shown at the top of the next page.

With the gradient drawn, go to the Filters menu, click 'noise' and 'add noise', setting the distribution to 'gaussian' and the radius to 3. Unlike before, we now need to draw a rectangular marquee. Press 'Shift + M' and cycle through the options until the rectangle option is displayed in the toolbox. Draw a marquee

**Start your gradient fill in quick-mask mode at the right circle is
and finish about where the left one is.**

around the white region underneath the 'right' image and directly over the semi-opaque red of our quick mask. Press 'Alt + Delete' to fill this with the foreground colour, which should be black (although you'll still only see the semi-opaque red).

We do this because when we added 'noise' to our selection, several hundred small holes were created that would become transparent when we delete the gradient selection in a few seconds, so this action increases our level of accuracy and the level of detail. Now press 'Q' again to re-enter normal mode and you will see our jagged-edged selection ready to do the business.

Simply press 'Delete' three times and you will see the problems that we had with detail – around the area where the two pictures merged – completely disappear! Now press 'Ctrl + D' to deselect the active selection and then merge the visible layers into one combined image, which we will retouch briefly either by going to the Layer menu and clicking 'merge visible' or by the keyboard shortcut 'Ctrl + Shift + E'.

Now press 'C' to select the crop tool, draw a marquee, trim the image on the top, bottom and the right-hand side and press 'enter'. *Voilà!* A perfectly finished panorama. These images were purposely selected to be quite far-out in terms of detail, so you could see how easy it is to realistically blend more than one image together. If you look very closely, there are a few gentle mismatches in the detailing in the centre of the image where the two parts

overlapped. Simple get rid of them in seconds with our old friend, the rubber-stamp cloning tool!

filters and software-bundled special effects

Filters are what normally get all the attention when people are looking at a piece of image-editing software. It doesn't matter what inherent power a piece of software has, if it doesn't have cool filters the lay person generally won't be interested. Fortunately, Photoshop has a set of the most comprehensive and creative filters around. Knowing what to use when and how these filters can actually enhance your images is a useful skill, and in the next chapter you will learn how to take any of these filters and apply them in the most controlled and artistic way. But for now, it's time to have a little fun 'fiddling with filters' – almost sounds like a TV show!

Filters can broadly be divided into three main categories: corrective, destructive and artistic. *Corrective filters* take an image and perform operations to normalise various aspects, *destructive filters* physically move pixels around an image to create a new shape and *artistic filters* take pixels and perform

mathematical operations on them to create recognisable artistic styles and effects. I'm not going to spend 27 pages (some authors really need a slapped wrist) explaining to you what each of the individual filters look like and do – you can simply try them and get a feel for how they can be used to enhance your work – but I will categorise them and highlight filters which warrant particular mention based on their degree of usefulness. You can reapply any filter to compound an effect by pressing 'Ctrl + F' and if you find a filter's effect too strong, you can press 'Shift + Ctrl + F' to blend the effect with the initial unfiltered image, thus lessening the strength of the filter. Let's have a look at what's on offer in each category.

corrective

These are the set of filters which are generally of most use to a digital photographer, as they can quickly manipulate an entire image with a particular highly controllable effect in the same way the autolevels and autocontrast can make instant quick-fixes to your whole image.

Noise menu

The noise sub-category in filters allows you to either add or remove different types of 'noise' that may be apparent in your digital photography.

add noise

Can be an artistic effect, but generally used for degrading an image's quality.

despeckle

This can be incredibly useful. Many scanned-in images will have specks of dust and grain present. A quick application of this filter will remove any minuscule traces of dots, dirt or unwelcome noise. This is also highly useful when you have scanned in a magazine image or a page from a newspaper, where close-up magnification will show the image is made up of thousands of tiny dots.

dust and scratches

This is a more heavyweight version of despeckle, which does the same as the previous filter but more so. It often leads to a marked degradation of quality, so you should use it sparingly and only on the pictures worst affected.

Masking heavily damaged areas and using this filter can protect main areas of detail and greatly improve an image's quality.

median

This filter looks at all areas of contrast on an image and will take any areas which appear to have large blotches and spots and remove them by using an average of the surrounding pixels. Median can be used to great effect with very damaged images, but will greatly reduce quality.

Sharpen menu

'Sharpen', 'sharpen edges' and 'sharpen more' are all useful and all self explanatory. If you get an image that for some reason has lost contrast or detail, using these filters will build it back in. Multiple use of 'sharpen' is better than 'sharpen more', as you have more control. Sharpen edges will only sharpen outlines.

'Unsharp mask' will reduce sharpness within an image and make it softer.

Blur menu

Blur could be considered corrective, artistic or destructive depending on what kind of image you start off with.

'Blur' is a standard blur effect, 'motion blur' can be directed in any direction along a horizontal plane, 'radial blur' gives the options of both radial and zoomed-in blur and 'smart blur' gives a little bit of everything but doesn't tend to get used often because of the unpredictable nature of the filter.

destructive

Destructive filters are the ones that are a whole lot of fun and always make people 'ooh' and 'aah' before they realise many aren't really that useful; certainly not in terms of digital photography at any rate. The Distort menu holds the destructive filters, all of which physically move pixels around an image in relation to a mathematical formula. Because you get great tools to control these filters, it is very easy to make something good looking, but you will get bored - and quickly. Some of the artistic filters boil over into the destructive filters category.

The destructive filters are displace, glass, ocean ripple, pinch, polar coordinates, ripple, shear, spherize, twirl, wave and zigzag.

artistic

Strictly speaking, any of the filters can be used for artistic purposes, but

there are a batch of filters that are only used for artistic purposes, as they contain no other redeeming features that could be practically useful in any other circumstances. Combining many types of filter, as demonstrated in the following tutorial section, is a great way to dip your fingers into digital art and develop an understanding of the true power of filters, not just the initial 'wow' factor.

The artistic filters are diffuse glow, and anything from the Pixelate, Stylise, Render or Texture menus.

Make sure you test all the filters at least once, so you get an idea of exactly what kinds of instant effects are at your fingertips.

painting filters for artistic effect: the History brush

Filters work on entire images or areas which have been masked off, which gives you fairly limited creative options, or does it...? Photoshop has a unique 'history brush' which, with a bit of sneaky manipulation, will allow you to paint any of the effects from the previous section with any brush shape or size, giving you an incredible amount of extra tools. For the history brush to work, you must use it in conjunction with the history panel, which is paired with 'actions' and is the second panel grouping from the bottom on the right-hand side of the screen. Make sure the history tab is clicked so the panel is active. The history panel is the equivalent of multiple undos. It allows Photoshop to log any brush movements, filters, colour adjustments and so on, so you can use a few filters or several other operations. It also enables you to see if they are doing what you thought they were going to. If not, simply click up several levels in the history palette to return to an earlier state. Let's test this out first. Open the 'image 1.jpg' from the 'Painting Filters For Artistic Effect' folder on the CD-ROM: there's a picture that'll frighten you for weeks... Now select the standard-brush mode and paint on the picture several times, as shown at the top of the next page, making sure you remove your finger from the mouse button each time and reapply. While you are doing this, notice that every time you perform an operation separated by mouse clicks, you will notch up another state in the history palette.

Now click on different logged states and you will see you are jumping in time! Click back on 'snapshot' at the top of the stack to return to the original image. Press the round circle with the right-facing arrow to select the History menu and click 'clear history', as shown overleaf (below).

You will see that to the left of the initial snapshot is a small paintbrush icon with a curved arrow attached to it. We are going to use the history brush in a

Notice the history palette increasing the number of logged states

second, but first we need to add some general filters and effects so we can have something for the history brush to use as a source.

First, go to the Image menu, select 'adjust' and then 'autolevels'. Now go to the Filter menu and select 'ocean ripple' with a ripple size of 7 and a ripple magnitude of 11. Click 'OK' and our picture starts to get weird. Now, access the History menu by clicking on the circle with the arrow and select 'history options': this is the key to the whole sequence. Click 'history options' and check the 'allow non-linear history' box.

History normally works in a linear fashion. That means that when you have logged various states, if you go back to an earlier state and start performing other operations, they will start logging and building up in the history palette from the history state you previously reverted to. By allowing history to work in a non-linear way, you can revert to a previous history state but maintain the changes live in the history panel, allowing you to carry out this next little piece of magic. Now that we have 'allow non-linear history' enabled, go back to the top of the stack and click on the initial image. You will see that the autolevels and ocean ripple filter remain open as options. Now click to the empty box to the left of the ocean ripple state to transfer the source location for the history brush.

Click in the circled location to shift the history brush source

Now press 'Y' to access the history-brush tool, or simply click on the history-brush icon in the tools palette on the left-hand side of the screen. Select a brush size as for all other tools, by clicking on the brush dropdown. I have selected a 45-pixel round soft-edged brush. Now, simply paint a nice snaking stroke, and see what happens...

Clever, eh? I have painted over these hapless fools' faces, but now you can see how you can paint any effect directly with the history brush. I am particularly fond of using the various stylistic effects and reverse-history brushing.

Re-click on the top snapshot in the history palette and click 'clear history' in the History menu. Go to the Filter menu and click 'brush strokes', then 'ink outlines', which creates a cartoon-style ink outline around areas of contrast in an image.

To reverse history brush, simply make sure the history-brush source is set on the initial snapshot, so instead of painting with an effect, you are painting the original image.

For a truly freaky effect, paint with a slightly smaller brush, say 35 pixels wide, over our hero's eyes to bring back 'real' eyes over the top of the cartoon edge. But we aren't going to stop there!

Now go to the History menu again and this time click 'new snapshot'. This creates another reference image that can never be deleted by mistake, with the initial snapshot at the top of the screen. Click back on the first snapshot, which will give you the initial image with no filters applied. Go to the Filter menu and this time select 'sumi-e' (one of my favourite stylistic filters). Now set the history- brush source back to the second snapshot we made and this time draw back over the hands and eyes of our group to give a weird cartoon, with real eyes staring back! Take a look at the image at the top of the next page.

This shows you the power of this particular tool. Suddenly we are very quickly heading from the domain of digital photography and image retouching to full-blown digital artwork.

Play around with this kind of compound painted filter, as you can easily create some stunning images and effects with next to no knowledge (or even skill, if I'm being perfectly honest!). It will also enable you to start thinking more creatively with your image-manipulation skills.

using text in images

Every piece of image-editing software has a text function. Adding text to images to create posters, flyers and the like – or even just adding a reminder of where a particular image was taken – is standard practice. However, the seeming simplicity of adding text to an image belies a host of potential pitfalls; after all, there is a whole branch of layout called typography, whose scope is far beyond the remit of this book. However, there is a lot of basic knowledge that is essential if you want to avoid pulling your hair out when you try to add text to your digital images.

text tech

Text is a word that may be unfamiliar to some of you; basically it means type, words, letters. Being able to lay out text where and when you want is essential, and to be able to do this, you must know a few technical terms.

First, go to the File menu at the top of the screen and click 'new'. Create a new

document of 800 X 600 pixels which has a resolution of 72dpi. When you have done this, press 'T' to activate the text tool and click on the white empty document near the upper left-hand side. Type in 'Hello, welcome to the world of text!' When you have done this, you will see that in the bottom right-hand panel a new layer has appeared with a big 'T' on it, to signify that this is a text-only layer. All image editors handle text separately from the way they handle the pixels that make up digital photos. Now, double click on this layer with the big 'T' and you will see a box appear around the text. This shows that the text has been selected.

Now the fun starts. Text can be set (set up) in a variety of different styles. This is determined by the 'fonts'. Fonts are different visual styles for text. Different fonts look good under different circumstances: when you write a company document, you need your text to be legible and easily read, so you may use a font like Arial, or Times New Roman; if you were creating a child's party invitation, you may want a slightly more fun font like Comic Sans. Your computer will have many fonts installed automatically, and any piece of software you have installed since, particularly creative software like Photoshop or PaintShop Pro, will have added an extensive list of new fonts that can be used by any programs. In the dropdown box, click on the font you presently have active. Select some different fonts and have a look at the breadth of fonts you probably never knew you had access to on your computer!

A selection of different fonts. People have different fonts on their computers, but there are always a certain number of fonts which are universal. Impact, Hettenschweiller, Arial, Verdana and Georgia are all examples of ones you should definitely have.

Size is the next important thing to consider. Fonts and text sizes are measured in 'points'. A point is an old typesetters' term for $1/72$ of an inch. So if you were to set your text size to 72 points, it would be one inch high. You can measure your text in centimetres, pixels and the like, but professionals do it in point sizes, so it doesn't make sense to rock the boat! Have a go at selecting different font sizes.

Different font sizes are measured in 'points' and 72 points make up an inch, although I'm sure the European Union will start moaning about that soon…

Point size is, as you can imagine, one of the most important considerations. When you are writing in a program like Word, normal text is generally 10 or 12 points, depending on the specific font you are using. When you are working in a graphical program, however, text looks slightly different. This is because text in graphics programs has 'anti-aliasing', which makes the text blend into the page instead of having harsh, pixelated edges. It can be turned off, but this is the reason your text may look different to what you were expecting. Further considerations, such as how large your text should be for different media, is discussed in the final section of this chapter.

Now, select a font you particularly like and give it a suitable size. I have to make the text quite large so you can see it in the screenshots! Double click on the text's layer and use the cursor keys to move to end of the line of text. Now press 'enter' and type something suitable to attach another line to this one. Do this again and we will have three separate lines of text all connected on the same layer.

Now we have three lines, you will be able to see what changes are made in the relationship between the lines when we modify some fundamental controls. Press 'T' to make sure the text tool is still active and click on 'palettes' to get the text controls on screen.

Double click on the text layer in the layers panel to make the text active and ready to be modified. In the text controls you will see you have the 'character

tab' active. These controls modify the relationship between individual letters and the distance between lines, as well as giving you access to the standard font size and font-selection tools. The two particularly important tools are on the right-hand side, but in many image-editing packages tools are losing their traditional names. Always a stalwart defender of T'way things were when I wuz lad..., the higher tool should be known as *kerning*, which is the vertical space between letters and characters, and the lower tool, *leading*, which is the horizontal distance between lines. In order to get your text to look right you must modify these two settings on a regular basis, as automatic settings never quite look correct. Modify these values and you will see subtle differences between the way the letters look when viewed together. It may not seem to be an important part of the process, but subtle modifications can make all the difference in the world when you want text on one of your treasured digital images to enhance rather than detract. The width- and height-scaling controls are self-explanatory and only useful if you need to stretch some text in one direction only.

The next tab is the paragraph tab and controls the way the entire collection of words on the individual layer operate. You can control how a paragraph is justified (does the text align to the left margin, right margin or is it centred?); the other controls are for modifying indentation. As always, the small round button on both tabs give you several more options. Those on the character tab give more 'word processing'-style controls such as underline and strike-through, but personally I find it better to add such things to text in Photoshop by simply drawing them, which offers you a greater degree of control. Under the paragraph tab you can change the specifics of justification and define exactly when automatic hyphenation kicks in.

making text look good

When you understand the basic tools, have a go at laying out different pieces of text on images. Unfortunately, you can't learn good typographic layout simply from reading a book. Damn shame! However, you can learn by practice.

Obviously, it doesn't take much for you to exercise a little common sense – not to lay great daubs of text over the main subject of one of your pictures and to make sure there is a suitable kerning setting – but you do need to develop a good eye for where text should go in proportion to other elements in your picture. So, go practise. Go on. Shoo!

This image has several pieces of text overlaying it, but it all holds together well. You may not know why, but when it works, you just know. How did I know? I used the 'eye' Muhahaahahaa...

text tricks

Thanks to modern digital technology, you are no longer restricted to boring old linear horizontal and vertical text. Photoshop, and most other image-editing solutions, carry a whole plethora of options to take your text into ever groovier dimensions.

Open 'image 1.jpg' from the 'Painting Filters For Artistic Effects' folder on the CD-ROM. It's our face-ache friends, back again, and this time we'll give them a suitable caption. Press 'T' to open the text tools and type on the screen, in white, 'A bunch of crazy, scary and very drunk Czech nutters!' Use the Arial font (or Helvetica, if you prefer) in bold and at 36 points. Now click at the top of the screen on the button that says 'palettes'. This will open a palette that contains all the text options. Click on the small circular button that has the right-facing arrow in it and you can open the text options. Make sure that the

'faux bold' option is turned off, as the 'text warp' tools we are going to use won't function if this command is left turned on.

Now click on the 'T' with a bending line underneath it at the top of the screen; this will open the text-warp controls. Click on the dropdown box and select the 'flag' option. This will start the text warping as if it were on a flag blowing in the wind. I have turned the amount of 'bend' (warp) up to 100% and have a perfect wavy piece of crazy text – just right for these guys! You should experiment with some of these settings as all the warps are useful in certain situations: a bulge warp, wrapping text around a large central image, or an arc of text rising like a rainbow over a group of friends. This kind of text warping is a lot of fun and can be practical and creative at the same time. Be sure to remember that you can completely alter all the warp effects by swapping their angle of influence from horizontal to vertical, although generally this produces slightly less usable results.

how text should be modified for different distribution formats

This is one of the areas of text usage within imagery that is used wrongly almost every time and consistently causes people to wonder why things keep looking bad. Given that you have been following all the tips in the previous sub-sections and you have managed to lay out all your text to make an incredible

poster, a great looking flyer – whatever – you have to think how people are going to actually see the image you have created.

Remember earlier in the section we talked about how to print images properly. The initial problem with printing was that your images looked great on screen but hadn't been correctly modified for a different distribution format, namely print. The same applies to text. Text needs to be, as we have discussed, directly proportionate to its importance but, depending on the format of distribution, your text needs to be altered accordingly.

If you have a photograph destined to be printed, even if your text looks too big when you are editing in your software, you must take into account the fact that the text will be pushing five times smaller and alter the size accordingly. Equally, the text should be repositioned so it hangs correctly when the image is printed.

Text of sizes 12 and 24 point, for example, are ample for descriptive text and headline text, respectively, when an image is going to be displayed on screen at 72dpi. When, however, you need a 300dpi resolution in order to print out at photographic quality, you need a minimum of 60-point text to be able even to squint at the printed version.

If you are viewing your images on a computer screen at 72dpi, the largest text size you would use for descriptive text is 12 point: anything larger and it looks as if you either have no layout skills or you need glasses. If you are out-putting direct to your TV screen, a function which many even mid-range cameras support these days, then you will be unable to read anything less than 18 point, which has a faux-bold width enhancement, because of the lower overall screen size available on a television. Clearly there are many pitfalls.

Colour is another stinker. When it comes to print, you can get away with any colour text. When it comes to monitors, however, any colours that are completely saturated (ie the very brightest colours) and placed against each other (a great example being bright red on bright yellow or bright blue on bright green) will create bleeding and the levels of contrast will begin to hurt your eyes.

Open the image in the 'text samples' folder called 'ouch.psd' and you'll see what we mean. For text outputting on a TV screen the problems are even more marked, even with dull colours that have much lower saturation. Always be careful when picking out colours; too many people think the best way to make text stand out is to make the colour the opposite of the colour of the area covered by the text, whereas making a small plaque, like the one in the screenshot, and typing standard white on black or white on dark grey, is more effective and looks a lot more professional.

A plaque can make text stand out more than just colouring text contrary to the background. However, you should think how relevant the text is to the image and whether or not the image requires such an intrusion: only use a plaque when you need the text to stand out and grab attention.

Another important thing to consider is your monitor's resolution. You may have a mega super-huge monitor running at a resolution of 1600 X 1200 pixels. This is great and I'm very happy for you (actually, just jealous!), but if you are intending to show your images on the internet or on CD-ROM, then you must remember there will be people viewing your work on monitors with a resolution as low as 800 X 600. You know what that means? They see everything twice as large, so even though your high-resolution monitor may make 24-point text look pretty tiny, other people will think you have a screw loose because you made your text so big. Always preview everything before you send it on to somebody else, or publish it online, by changing the resolution of your monitor. You can do this on PCs by clicking 'start', then 'settings', then 'control panel', double clicking 'display' and selecting the settings tab. You will see that you can use the slider to change the resolution of your monitor (a safe preview level is 1024 X 768), which will let you gauge more accurately what people are likely to see. This is fairly much the standard these days, although some people still use a resolution of 800 X 600.

sponging, smudging, blurring, sharpening, burning and dodging

Not to be confused with Dave Dee, Dozy, Beaky, Mick and Tich, this suite of tools provides you with the ability to really fine-tune images, with each tool able to subtly alter the appearance of pixels. These are the tools that you would be using to make Madonna wrinkle-free and give her the skin of someone 20 years her junior. Combining all the above tools in an image allows for extra fine-tuning of an image, as it is rare that every single area of a digital photograph will be perfectly proportioned when snapped and transferred to your computer.

the sponge tool

The sponge tool is great for softening pixels in an image. The tool removes both saturation (the amount of colour, not its tone, within a pixel) and contrast (the difference between tones and brightness levels of congruent pixels). It can also be set to increase saturation and contrast, making it a more heavyweight tool than the singular sharpen tool.

the smudge tool

Smudging simply smears pixels from one location to another. Imagine dragging your finger over a blackboard with chalk on it: when your finger touches chalk, it gets smudged in the direction your finger is moving, blending with any other colours below it. Smudging works particularly well when you need to smooth out and blend between similar tones in an image.

the blur tool

Most people know what a blur looks like, but not what it actually is. The blur tool blurs underlying pixels by reducing the amount of colour contrast between congruent pixels. As contrast is reduced, the neighbouring pixels gradually become closer and closer to each other's respective RGB values.

the sharpen tool

The sharpen tool does the opposite of the blur tool and increases the levels of contrast between congruent pixels. When using any of these tools, you can increase the pressure (better thought of as the pixels' sensitivity to the tool), but this can have the effect of creating over-sharpening, as two drags of your brush with sharpen set to 80% gives a compound effect of 160%. Keeping sensitivity low (50% or below) but using the tool in conjunction with the 'Shift' key doubles the present strength of the tool, enabling you to quickly modify

sensitivity without overcooking an image. More on this in the practical section coming up!

the burn tool

The burn tool allows you to darken pixels within an image depending on which colour you have selected as your foreground painting colour. If you are painting with a lighter colour than the pixels you are painting over, there will only be a visible change in pixels that have lower darkness levels.

the dodge tool

Dodge does the opposite of burn and lightens the portion of an image you paint over. As with the other tool, it will only lighten to the threshold of the colour active in the foreground colour box, so any colours darker than the colour of your present brush will become as light as the colour in your present brush, but no more.

A combination of several of these tools is often one of the very best ways to seriously fine-tune an image. So far in colour correction and general image manipulations we have been working with fairly large parts of an image. Although this is often the best way to achieve fast, good-looking results, there will be times when you want to really focus on the detail, and this requires different parts of an image to have small parts sharpened, blurred or burned to get the best quality possible. So let's now give this a try under a number of circumstances.

Open Photoshop and navigate to 'image 1.jpg' in the 'Sponging, Smudging, Blurring and Sharpening' folder. You can see that our hero pooch appears to lack contrast because some evil photographer has got too close with a flash. As a result, the pair of bum-cheeks on the right of the picture have become flat and lifeless. By using a combination of sharpening, sponging and burning, we will modify colour saturation, detail and sharpness to make a so-so fun shot into a perfectly set-up final product.

First, click 'Images', 'Adjust' and 'Autocontrast' so we can generally brighten and increase contrast where the flash was present in the image, as shown at the top of the next page.

Now zoom into the dog's head with the zoom tool (shortcut 'Z'). You will see that in the area below, where the flash dominates, there is good detail, colour and definition, but on the dog's head, this is somewhat lacking. Obviously, in areas that have no detail, it will be very difficult to create it, but the small

differences in colour that do exist can be safely amended to provide a better overall feel to the main subject. First, select 'sharpen', by pressing 'R' and 'Shift' until the right tool appears active. From the Brush menu at the top of the screen, select a mid-sized soft-edge brush (I am using a 13-pixel-wide brush). The soft edge here is useful as it will reduce the influence of the sharpen tool towards the edges of the brush, allowing more specific direction and blending with the tool. Change the pressure to 35%. As when working with very light tones, the sharpen tool can add too much contrast and spoil an edge-enhancing effect.

Zoom in close to the dog's lower left-hand ear.

Now with the brush, make small strokes along any areas of detail; these will be the edges of the hair where the flash hasn't completely blanched any highlights. Always move the brush in the natural direction of the hair: from root to tip. By sharpening just the edges, more detail is created in the picture, although still quite subtly, and the graduated fall-off of the tool means there will be some sharpening in the middle of any hairs without over-sharpening the image. Continue to sharpen the muzzle and top of the head and follow through to finish the right-hand side. Now zoom out again and look at the subtle, but clearly noticeable difference in definition and detail.

Now we want to reduce some of the glare coming from the flash, to normalise the picture. We couldn't use 'autolevels' for this as it would simply make the massive flash glare even worse. Select the burn tool by pressing 'Shift + O' until the hand icon that represents the burn tool is visible. For this particular image, the default settings are fine. Keep the same brush size that you used for the sharpen tool and daub the very bright highlights around the face and muzzle: be sparing as we want to keep some highlights and not over-darken the image. As with all these retouching tools, they are cumulative, so be careful not to go over the same area many times or you will over-burn, as shown in the screenshot.

Face on fire! This is an extreme example of over-burning, where all the dark tones have been turned black and contrast and detail have been ruined.

Now our subject is looking a lot happier, but what are we going to do with that poor, poor bottom? All colour within the secondary subject (OK, to be honest it just happened to be in the picture, but let's not look a gift horse in the mouth!) has been blanched by the flash and the fairly vibrant image has a very flat, lifeless-looking posterior. Because this part of the picture is not meant to detract from the main subject, we don't want to add any more detail to it, but we do need to spruce up the colour levels in this part of the image. Fortunately, this is what the sponge tool is for.

First, we need to separate the bottom and legs from other parts of the background, or the sponge tool will lead to extra colour everywhere and spoil the effect we are trying to achieve. Use the pen tool as the contours of the jeans are particularly easy to cut away with smooth curves in this image. Click in the path tab in the bottom right-hand docked panel and 'Ctrl' and click on the path to change it to a selection marquee. Don't feather this selection as the sponge tool will spill colour saturation outside the boundary we have created.

Now select the sponge tool ('Shift + O') and swap desaturate for saturate, so instead of colour being sucked from an image with the tool (like a sponge), it is flooded back into the image. This is where the recognition of HLS instead of RGB is useful (check the glossary!). Set the pressure to 20%, as if we over-saturate the jeans, they will become too prominent within the scene. Select

a large brush (I am using a soft-edged 200-pixel-wide brush) and stroke the bum (did I really just write that?) from the top of the screen to the bottom, with a different stroke for each leg. Make two more strokes and click around any areas which are still under-saturated. Remember, if you over-saturate you can either 'Ctrl + Z', or simply swap the saturate option back to desaturate to start removing colour!

Now swap the brush size for a more manageable 65 and press 'Ctrl + D' to deactivate the marquee selection. Now we want to continue burning, but this time click the mouse a few times on the other side of the picture, where the guitar has caught a lot of light reflection. This removes a bit of the glare, while keeping a believable highlight in shot at all times.

And there you have it! Take a look at the two pictures and see the difference in colour balance, detail, contrast, saturation and more: a perfect and highly detailed piece of digital-photo retouching!

Now open 'image 2.jpg' from the same folder. This time, we have an over-detailed, over-sharp image with little or no depth of field. By using a combination of the other tools we didn't need in the last tutorial, we can improve this image massively.

This image has a lot of fine detail on the sculpture, but the image doesn't work because of the flat, dark and heavily detailed background. Equally, there is very little colour saturation as the photo was taken on a heavily overcast day. By decreasing some detail and increasing overall lightness and colour, we can change this drab image to a lively, bright and fun image.

First, select the Image menu, then 'adjust' and select 'autocontrast'. This image, again, benefits greatly from enhanced highlights and defined shadows. Try using the 'autolevels' command instead though, and you will see why I am often hesitant to recommend it (although it seems to be the staple tool of many Photoshop instruction books!). With autocontrast selected, the colours in the picture remain suitably coloured for the operations we are going to perform. If you change the levels and alter the base colours, you will modify bad colours. With autocontrast at least you still have the colours as they were initially taken. Now select the colour-dodge tool by pressing 'Shift + O' until the tool appears (it looks like a black lollipop). Select a soft 100-pixel-wide round brush and leave the default settings, with mid-tones selected and a pressure of 50%. Now draw a wiggly, tapering line that looks like the black area of the guide image in the screenshot. Don't worry about being accurate: have some wiggly fun!

You don't need to be accurate when you are painting with the dodge tool here – look at the instant better levels of brightness – but thanks to the way the dodge tool works, we have also added a previously non-existent degree of depth and perspective.

Now select the blur tool. Quick-select by pressing 'Shift + R' until you see what looks like a big teardrop, which is the blur tool. Select a brush size with soft edges of about 100 pixels (although this can be down to your personal preference). Use the tool to 'paint' over the area shown in the next screenshot. You will need to go over to the far right-hand side of the image several times to further compound the blurring and create an effect that makes the shot look out of focus. What this is doing is adding more to the perceived perspective of the picture. The lightness at the front and the darkened area which blurs at the back are now really making this image come alive. Take a look at the screenshot at the top of the next page.

Finally, we want to zazz up the colour levels in parts of the picture, namely the far-left foreground and directly over the subject. Select the sponge tool and set the mode to 'saturate'. Select a 65-pixel soft-round brush and paint over the black areas with the saturation mode of the sponge tool, to bring some much-needed oomph to the picture.

Blur in the black areas, but go over the far right-hand side several times to increase the blur, which gives a greater depth-of-field illusion.

Finally paint over the black areas with the saturation mode of the sponge tool to bring some much-needed oomph to the colour levels in the picture.

You will need to make several strokes to get the required level, but don't overdo it. Spend a bit of time giving the subject a really vibrant gold hue, without going all Imelda Marcos, and there you have it – a vivid, lively picture saved from the clutches of poor photography! Check out 'Image 2 Finished' to see what I came up with – much better than the original.

from photographer to digital artist

There is very little distinction in the world of digital imagery between a competent digital photographer who has mastered Photoshop (or their other image-editing package of choice) and a full-blown digital artist. Digital artists often either use digital photography or other scanned-in imagery and combine various shapes, layers and blending modes to create a composite that is referred to as digital art. Digital art, like all art, is subjective, but if you can create an attractive piece of imagery and use elements of your digital photography in it, then there is very little to differentiate you from a digital artist.

To give you a start in the right direction, buying magazines such as *Digital Creative Arts*, *Computer Arts* or *Digit*, which focus specifically on the more artistic side of computer imagery, is a great help. The skills you will have picked up in this book will help you on your way, but for high-end tips on creating digital art and where to get further skills to achieve these ends, these are the people to check out.

Art is subjective, so maybe you already are a digital artist purely by virtue of your digital photography. You decide!

photographic institutions and societies

Joining a professional photographic organisation is a must if you want to be taken seriously or even just want to be part of a more focused circle of fellow photographers. You should take into consideration that digital photographers are the new kids on the block and there is still some friction between traditional photographers and their newer, fresher (ahem) digital counterparts.

UK photographic institutions and societies

The Association Of Photographers
This association focuses on the promotion of advertising and editorial photographers. It is very proficient in helping its members contact useful resources such as agencies, and also assisting staff at post-production houses. Membership is based on an annual fee that ranges from £72 up to £355.

The Association of Photographers
c/o Association Secretary, Gwen Thomas
81 Leonard Street
London
EC2A 4QS
UK
Tel: +44 (0)20 7739 6669
Fax: +44 (0)20 7739 8707
www.aophoto.co.uk

The British Association Of Picture Libraries
This is the organisation that represents all picture libraries and photo agencies in the UK. It is responsible for both UK and worldwide issues relating to technology, copyright of materials and more. It publishes a definitive guide

to UK picture libraries, which is much more detailed than the small starter listing in this book.

The British Association of Picture Libraries
18 Vine Hill
London
EC1R 5DZ
UK
Tel: +44 (0)20 7713 1780
Fax: +44 (0)20 7713 1211
e-mail: enquiries@bapla.org.uk
www.bapla.org.uk

The British Institute Of Professional Photography

As well as having one of the coolest web addresses in the world, BIPP is a union for professional photographers, so when you start earning money from your imagery, it's a good idea to join. The society governs professional examinations and publishes standards of conduct to safeguard public and professional interests. It was founded in 1901 and remains one of the powerhouse photographic institutions.

The British Institute of Professional Photography
Amwell End
Ware
Hertfordshire
SG12 9HN
UK
Tel: +44 (0)1920 464 011
www.bipp.com

The Master Photographers' Association

With a yearly subscription of £99, this society protects the interests and promotes the virtues of professional photographers.

The Master Photographers' Association
Hallmark House
1 Chancery Lane
Darlington
County Durham
DL1 5QP
UK
Tel: +44 (0)1325 356 555
Fax: +44 (0)1325 357 813

The National Museum Of Photography, Film And Television

This museum focuses on all aspects of photography, but also incorporates other media for creativity including film and television. The museum has a renowned collection of over 3 million items and anyone interested in any aspect of photography could do worse than take a look. At certain times of the year, you can have face-to-face sessions with the country's leading photographers, which is a wonderful and inspiring experience.

The National Museum of Photography, Film and Television
Bradford
West Yorkshire
BD1 1NQ
UK
Tel: +44 (0)870 70 10 200
Fax: +44 (0)1274 723 155
www.nmsi.ac.uk/nmpft/

The Royal Photographic Society

As a digital photographer, this is the society to join. It has completely open membership: there is no grey area at which you become a 'professional' and thus entitled to membership. The society promotes the art and science of photography and electronic imagery in general. It publishes the monthly periodical, *The Photographic Journal*, and the quarterly, *Imaging Science*. The Royal Photographic Society is a keen proponent of all digital photographic technologies and the new avenues for creativity they encompass.

The Royal Photographic Society
The Octagon
Milsom Street
Bath
BA1 1DN
Tel: +44 (0)1225 462 841
Fax: +44 (0)1225 448 688
e-mail: rps@rps.org
www.rps.org

US photographic institutions and societies

Advertising Photographers Of America: New York

This is a society for New Yorkers involved in photography within the advertising industry. It is the premier resource for community, culture, commerce and publications relating to publication photography and is the authoritative voice of publication photographers worldwide.

Advertising Photographers of America: New York
27 West 20th Street
Suite 601
New York
NY 10011
USA
Tel: (+001) 212 807 0399
www.apany.com

The American Society For Media Photographers
A major worldwide society for anyone involved with photography for media. Despite claiming to be a worldwide organisation, which it is, the society is first and foremost there to represent photographers working in the US mass media.

The American Society for Media Photographers
150 North Second Street
Philadelphia
Pennsylvania 19106
USA
Tel: (+001) 215 451 2767
Fax: (+001) 215 451 0880
www.asmp.org

The Optical Society Of America
An organisation for anyone involved in the study, engineering or - if you're that way inclined - love of optics, which is, of course, another name for lenses, hence the photographic insinuation!

The Optical Society of America
2010 Massachusetts Ave NW
Washington DC 20036
USA
Tel: (+001) 202 223 8130
Fax: (+001) 202 223 1096
www.osa.org

The Photographic Society Of America, Inc
This society is a worldwide, interactive organisation for serious amateur photographers, professional photographers, or anyone with an interest in photography. It publishes a monthly magazine, runs photo competitions, study groups via mail and on the internet, and runs an annual conference, held in a different US location each year.

The Photographic Society of America Inc
3000 United Founders Blvd
Suite 103
Oklahoma City
OK 73112 3940
USA
Tel: (+001) 405 843 1437
Fax: (+001) 405 843 1438

The Society For Photographic Education
The Society for Photographic Education is a non-profit membership organisation
that provides a forum for the discussion of photography-related media as a
means of creative expression and cultural insight. Through its interdisciplinary
programmes, services and publications, the society seeks to promote a broader
understanding of photographic media in all their forms, and to foster the
development of their practice, teaching, scholarship and criticism.

The Society for Photographic Education
110 Art Building
Miami University
Oxford
OH 45056 2486
USA
Tel: (+001) 513 529 8328
Fax: (+001) 513 529 1532 (mark for the attention of SPE)
www.spenational.org

worldwide photographic institutions and societies

The Australian Photographic Society
Possibly the worst-looking website in the world, ever, and yet conversely one
of the best-featured photographic society websites around. The society runs
exhibitions, conferences, activities, training seminars and more, and is a great
place to get into photography in Aus.

The Australian Photographic Society
185 Breton Street
Coopers Plains
Queensland QLD 4108
Australia
Tel: (+61) 07 3345 7269
Fax: (+61) 07 3345 7269
www.members.optushome.com.au/ausclubs/apsm

The International Association Of Panoramic Photographers
A bit of a mouthful, but one of the only societies dedicated to this interesting and popular genre of photography. The society is particularly welcoming to digital photographers, given the way in which digital photography has helped increase the popularity of this type of imagery.

The International Association of Panoramic Photographers
8855 Redwood Street
Las Vegas
Nevada 89139
USA
www.panphoto.com

The Malta Photographic Society
137 Old Bakery Street
Valletta
Malta
Tel: (+356) 2124 2265

The Photographic Society Of New Zealand
This society is a community that enables New Zealanders with a love of photography to get together and share ideas and pictures.

The Photographic Society of New Zealand
PO Box 98
Wanaka
Central Otago
New Zealand
Tel: (+64) 03 443 9176
www.photography.org.nz

La Société Française de Photographie
The French Photographic Society offers similar services to its counterparts in other countries. France has a particularly strong association with photography, since the very first photographs were created by the Frenchman Louis Daguerre. If you're French and into photography, digital or otherwise, you should be a member.

La Société Française de Photographie
71 rue de Richelieu
75002 Paris
France
Tel: (+33) (0)1 42 60 05 98

Fax: (+33) (0)1 47 03 75 39
e-mail: sfp@wanadoo.fr
www.sfp.photographie.com

Most other countries now have at least one major photographic society so there are too many to list overall. The above list represents some of the larger or more prominent of these societies. If you are in a country with no photographic society or organisation listed, a web search will at least be able to put you in the right direction. If you don't have access to the internet or cannot find the relevant information you require, it is always worthwhile getting in contact with your government's department of culture, which will have details of any major photographic societies or organisations in your country.

working in the photographic industry

Photography is one of those great creative industries where you get well paid for doing something you love. That's right: if you have a good eye for an interesting photograph, there are all manner of different outlets that you can sell images to. It's true that this is one of those industries that is very hard to enter. After all, you can imagine how many other people would love the prospect of earning money to jet off and snap interesting events, people and locations. Many people get into photography very young and have taken various GCSEs and college courses early in life. It is fortunate, though, that whereas techniques described in this book can be learnt, a good eye for an interesting photograph is something that can be developed, but never taught.

There are three major fields of photography that will immediately be apparent if you hear the photographic industry calling you. Commercial photography (weddings, portraits, product shots for brochures and the like), publication-related photography (encompassing the exciting stuff such as the legendary paparazzi or the incredible National Geographic-style photography) and the artistic (the moving and thought-provoking that everyone wants to be able to shoot, until practicality intervenes).

If you want to be a full-time photographer, taking further advanced courses in the art is a good starting point, but generally this should take a major backseat while rudimentary business skills are sought. If you want to be able to support yourself with your art, you need to be able to pay the rent and put food on the table. A new photographer won't have years of contacts, good relationships with image-commissioning editors or maybe even an idea about where to start being able to tout his or her work. An evening course in basic accountancy and business practice will open your eyes as to: (1) How to go about finding paid outlets for your imagery and (2) What you need to consider financially before you could sustain any form of photographic lifestyle. Suffering for your art sounds very praiseworthy and melodramatic, but today you are more likely to be considered a daydreamer.

The first and foremost thing that will enable you to even consider a career in any part of the photographic industry is to have a good portfolio. Even if you are trying to get a position in a shoe company, photographing soles, you still need to be able to show the person who may be employing you that you could make the most moribund slab of rubber composite look like a Hollywood movie star. Even seemingly dull subjects want to be seen as sexy, special and interesting. A portfolio should only ever contain your very best, most dynamic, most thought-provoking images. If your attitude to even one image is, 'Well, it's quite nice and somebody might like it', then you've got a potentially career-stunting flaw in your portfolio.

How do you make sure that your portfolio is up to scratch? Ask people to look at it. First, ask them which photos they like and ask them *why* they like certain images. Everybody has subjective opinions about things and, more often than not, they will respond well to certain stimuli for reasons that you haven't even considered. Ask people of different sexes, different ages, from different industries and walks of life and keep a log of all the comments about your photography. When you have quizzed a lot of people, modify the content of your portfolio to reflect the feedback you have gathered. Ask the same people again and hone your content. Now, you should find a professional photographer; most of us are fairly easy-going and would be more than happy to have a look at your portfolio. There's nothing worse for us - or an aspiring photographer - than looking at a poorly considered portfolio and having to give an honest appraisal. On more than one occasion, I have had to tell the truth about images that just didn't hold together well with the rest of the portfolio's content.

I always find that a good size for a complete portfolio for someone looking to get work in the industry will consist of four to six good landscape shots and a similar amount of portraits or life shots. Also include some obviously commercial images: being able to show an understanding of the business end of photography with some well-proportioned and well-lit product shots, is useful to any commissioning image editor. Even if you are being considered for celebrity stalking, a selection of strong, vivid, artistic photographs enables the person looking at your portfolio to gauge your creative eye. Don't forget to include a few sets of photographs on a similar theme - maybe action or nature or whatever excites you - as this allows you to demonstrate some more flair. By showing a portfolio completely jam-packed with one style of photograph, you may demonstrate a great deal of competence to the person appraising your portfolio, but you show very little of your ability to adapt and capture imagery in a different way - essential in even the most seemingly dull section of the industry. It's always good to modify your portfolio slightly depending on the type of position you're seeking. If you are trying to land a plum contract for taking shots of holiday destinations (and while I'm dreaming, I'd like a pony - even I've never

been able to nail that one!), the inclusion of extra landscapes, particularly those from exotic destinations, will obviously stand you in better stead.

The commercial photography industry holds the biggest and best chances for establishing a good foothold. Think about every product catalogue, every holiday brochure, every poster: almost everything has some element of photography in it. If you are young and don't have a massive number of financial obligations, it can be very useful to become a photographer's assistant. One of my best friends started out on this route and within a year and a half he was regularly getting his own commissions – mainly for weddings, parties and corporate events – but it enabled him to build up a solid commercial reputation that gave him the base and time to put together an impressive portfolio. Within three years he was touting photographs to specialist-interest magazines and earning good money!

If you are a little older and haven't the time or inclination to follow around and help out somebody doing what is considered to be the dull end of the industry, you can – as in all areas of life – bypass a lot of the donkey work, providing your technical abilities and portfolio are both up to scratch. Going straight for the jugular often helps, as ultimately when you approach a company there is generally a tacit belief that you will be capable of doing the job you are going for. Immediately sending letters of introduction to a marketing department or photographic agency outlining your skills and particular areas of interest can yield a surprising amount of rapid penetration; very few agencies or companies with strong photographic requirements will pass up a competent, hard-working photographer, and even if no work is available initially, getting your name around is always a good thing. Of course, you will need to show your contact with the relevant company your portfolio, your commercial nous and your ability to sell yourself as much as your photographs. These skills are generally intangible and hard to learn: ability comes with experience and practice!

Remember, that when you go for any photography job, you will need a solid CV focusing on your photographic side, but don't forget skills like Photoshop. Image editors don't just want raw photos (well, many do – but times are changing) and will often require that photos come in a digital format at a specific resolution and are already retouched so they are ready to be published that little bit faster. Making specific mention of your digital photography and image-manipulation skills is a guaranteed big plus in almost everybody's books.

Picking your target market when you have a solid portfolio and some commercial experience behind you is the next phase. Specialists often get a lot more paid

work than generalists. It's all well and good going to a commissioning editor or marketing manager and saying that you are great at photographing, say, the cars that the company makes; but the person who goes in and says, 'I've been photographing classic and modern cars for years and can do something really special if I start photographing for you' has the edge. The specialist (regardless of how specialist he or she actually is!) is the one who is going to get the commission. It isn't just specialists in particular fields who get the work: those who specialise in taking interesting angles, perspectives, or use interesting lenses are the types of specialists who often get commissioned again and again; try and make yourself unique even if you are a generalist!

Today everyone wants to be a professional photographer, so it is important that you know how to approach companies and sell yourself. Even a college course that teaches you the basics of business so you don't get swallowed up can't tell you how to make somebody react to your solicitations in a positive way. First, you should be thinking of volume. If you send off 100 letters of introduction, it is still unlikely that – as an unknown – you will suddenly get interviews to show off your abilities. This is where the digital skills you have been learning come into their own. Sending a CD-ROM (see Outlets For Digital-Photography Distribution) allows you to distribute a massive selection of imagery, but more importantly it shows that you know how to make it look good not just on a printed photograph, but on a much lower-resolution computer screen. This means that you can optimise your top-quality, high-resolution images for a computer monitor and save them in a 'view on monitor' folder, while saving the retouched, colour-corrected, high-resolution images in another folder labelled 'high resolution for printing'. This kind of consideration for the person you are trying to impress does wonders, not necessarily for getting commissions, but by opening doors so you can show off your full-sized imagery. Including professional stationery, letterheads, business cards and so on is essential to make you look the real deal and is a very easy and relatively inexpensive way to break down otherwise unpassable barriers.

When you do get an interview, it is essential to show off your work in the best possible light. Printing small, normal print-sized images isn't going to work. You will need to have taken digital photographs with a professional digital camera and professional lens. You can get by with a 3+ mega-pixel commercial digital camera, but if you are serious both about getting into the photographic industry and doing it digitally (it's the future – I'm telling you!) then you should be spending upwards of £1,500 ($2,250) on a top-quality digital camera with a dock for swapping lenses. Spending more on full professional-quality lenses thereafter will enable you to easily match and improve over high-end traditional camera photography. Initially, you will also need to ensure that any company you approach is willing to consider imagery in a digital format: newspapers,

magazines, publishers and others are often happy to accept digital photography as long as the quality is good enough and the resolution high enough to be printed in the relevant end publication.

Despite many agencies still being orientated towards traditional analogue photography, if your work is good enough you should still be able to get a foot in the door. Contact enough companies and you will get that elusive first commission before long!

There is an organisation I personally recommend as being an excellent society for anyone involved in freelance photographic work:

The Bureau of Freelance Photographers
Focus House
497 Green Lanes
London
N13 4BP
UK
Tel: +44 (0)20 8882 3315
Fax: +44 (0)20 8886 5174

The society provides an invaluable resource by offering all manner of advice for anyone within the industry. There is also a monthly newsletter, all at the price of £40 per year.

but how professional is professional?

Professional is simply a measure of whether or not other people are willing to pay you for your time and effort in a specific field. This means that if you start taking digital photographs and an image editor at a magazine commissions your work, you are a paid freelance professional. Simple as that. Of course, purists would state that a professional is only someone who can fully support themself with income from working in a specific field, so if you only get two commissions a year you don't count. Personally, I think if you can get paid for doing something, then you're a pro.

If you, too, are willing to take on this avant-garde approach to professionalism, you will find that many of the boundaries in your own mind ('Am I good enough?', 'Will other people like my work?' etc) are immediately blown away. If you get paid to perform a piece of restoration on a photograph and the client is happy, then you've entered the professional world. If an image library sees you have a perfectly taken, extremely high-resolution image of something unique and original, and is willing to pay you for it, you've become a professional. Use

this boost to force yourself to go out and find more work, take better pictures and do more image manipulation, and when everything is second nature, you'll wonder why you were ever hesitant about whether or not your skills were good enough.

To help you on the rocky road to professional recognition, you need to know who can offer a potential outlet for your photography. The following is a selection of some relatively mainstream picture agencies and picture libraries, which may be willing to take on some of your work; chance favours the bold! For specialist magazine work, it is a good idea to get a copy of the particular magazine for which you wish to photograph and contact the image editor direct, as general letters of introduction are often just an inconvenience in the fast and stressful world of periodical publishing (many image editors these days go straight to an image library for the sake of convenience).

One important point: any image library, like any magazine, will only want interesting and unique images, as they have many other stock images already available of the more 'standard' shots and have been accumulating them over many years. Interesting, innovative and unique shots will get bought. Targeting specific libraries and agencies with which you have strong photographic links and offering them something unique and specific that they may not already have on their books is a great way to enhance you commercial chances. With all agencies, check first to see if they are receptive to digital photographs.

agencies and libraries

Academic File New Photos

This library supplies many newspapers and magazines in the UK and has an extensive library of general art, culture, places and people. It has a specific bias towards photography from Asia, the Middle East and North Africa (Tunisia, Egypt, Morocco) and was founded in 1985.

Academic File New Photos
Eastern Art Publishing Group
PO Box 13666
27 Wallorton Gardens
London
SW14 8WF
UK
Tel: +44 (0)20 8392 1122
Fax: +44 (0)20 8392 1422
afis@eapgroup.com

Ace Photo Agency
Founded in 1980, Ace is a general photo library, covering all mainstream areas, including sport, entertainment, people, manufacturing, industry and history.

Ace Photo Agency
2 Salisbury Road
London
SW19 4EZ
UK
Tel: +44 (0)20 8944 9944
Fax: +44 (0)20 8944 9940
e-mail: info@acestock.com
www.acestock.com

Action Plus
This is a specialist sport and picture library that covers all professional and amateur sports worldwide. It also operates an online digital archive and thus may be more susceptible than some agencies to high-quality digital photography. Founded in 1986.

Action Plus
54–58 Tanner Street
London
SE1 3PH
UK
Tel: +44 (0)20 7403 1558
Fax: +44 (0)20 7403 1526
e-mail: info@actionplus.co.uk
www.actionplus.co.uk

Lesley And Roy Adkins Picture Library
This is a specialist architectural image library, specialising in ancient sites of architectural interest, including Egyptian, Roman and Greek. Founded in 1989.

Lesley and Roy Adkins Picture Library
Longstone Lodge
Aller
Langport
Somerset
TA10 0QT
UK
Tel: +44 (0)1458 250 075
Fax: +44 (0)1458 250 858

Adobe Interiors Photographic Library
Founded in 1993, this is a colour-photo library that deals specifically in interior shots of housing in England and Scotland.

Adobe Interiors Photographic Library
Albion Court
1 Pierce Street
Macclesfield
Cheshire
SK11 6ER
UK
Tel: +44 (0)1625 500 070
Fax: +44 (0)1625 500 910
www.sldirect.co.uk/adobe/contact

Aeroflims Ltd
This is a unique library of aerial photographs taken over the entire UK landmass. Founded in 1919.

Aerofilms Ltd
Gate Studios
Station Road
Borehamwood
Herts
WD6 1EJ
UK
Tel: +44 (0)20 8207 0666
Fax: +44 (0)20 8207 5433
library@aerofilms.com

AKG London
AKG is German and stands for Archive fur Kunst (Archive for Art). Its principal interest is in art, archaeology and history. It presently includes all 10 million images held by the AKG in Berlin and was founded in 1994.

AKG London
The Arts and History Picture Library
5 Melbray Mews
158 Hurlingham Road
London
SW6 3NS
UK
Tel: +44 (0)20 7610 6103

Fax: +44 (0)20 7610 6125
e-mail: enquiries@akg-london.co.uk
www.akg-london.co.uk

Bryan And Cherry Alexander Photography
An image library that focuses on regions inside the Arctic Circle, with particular interest in the indigenous peoples and tribes. Founded in 1973.

Bryan and Cherry Alexander Photography
Higher Cottage
Manston
Sturminster Newton
Dorset
DT10 1EZ
UK
Tel: +44 (0)1258 473 006
Fax: +44 (0)1258 473 333
e-mail: alexander@arcticphoto.co.uk
www.arcticphoto.co.uk

Allied Artists Ltd
One of the oldest image libraries, containing images of children and childcare. Founded in 1874.

Allied Artists Ltd
31 Harcourt Street
London
W1H 1DT
UK
Tel: +44 (0)20 7724 8809
Fax: +44 (0)20 7262 8526
e-mail: info@alliedartists.ltd.uk
www.alliedartists.ltd.uk

Ancient Art And Architecture Collection
Triple A is a particular specialist of the ancient histories of Europe, Asia, the Middle East and the Americas, with a specific focus on art, architecture and people.

Ancient Art and Architecture Collection
Suite 7, 2nd Floor
410–420 Rayners Lane
Pinner

Middlesex
HA5 5DY
UK
Tel: +44 (0)20 8429 3131
Fax: +44 (0)20 8429 4646
e-mail: library@aaacollection.co.uk
www.aaacollection.co.uk

Aquarius Library
A showbusiness image library with constantly updated material.

Aquarius Library
PO Box 5
Hastings
East Sussex
TN34 1HR
UK
Tel: +44 (0)1424 721 196
Fax: +44 (0)1424 717 704
aquarius.lib@clara.net

BBC Natural History Unit Picture Library
This library is one of the major holders of wildlife photography from around the world and was founded in 1995.

BBC Natural History Unit Picture Library
BBC Broadcasting House
Whiteladies Road
Bristol
BS8 2LR
UK
Tel: +44 (0)117 974 6720
Fax: +44 (0)117 923 8166
e-mail: nhu.picture.library@bbc.co.uk
www.bbcwild.com

Bird Images
This library specialises in ornithological images from the UK and Europe. Founded in 1989.

Bird Images
28 Carousel Walk
Sherburn in Elmet

North Yorkshire
LS25 6LP
UK
Tel: +44 (0)1977 684 666
Fax: +44 (0)1977 684 666

John Birdsall Photography
This library holds imagery relating to contemporary social documentary such as youth, old age, disability, health, housing, society at large. Founded in 1980.

John Birdsall Photography
75 Raleigh Street
Nottingham
NG7 4DL
UK
Tel: +44 (0)115 978 2645
Fax: +44 (0)115 978 5546

The Anthony Blake Photo Library
This library holds imagery relating to food, ingredients, food preparation, restaurants, markets, agriculture and the like. Still expanding fast, contributors are welcome, but check with the library about specific requirements.

The Anthony Blake Photo Library
54 Hill Rise
Richmond
Surrey
TW10 6UB
UK
Tel: +44 (0)20 8940 7583
Fax: +44 (0)20 8948 1224
e-mail: info@abpl.co.uk
www.abpl.co.uk

Book Art And Architecture Picture Library
This image library focuses on modern and historical architecture: buildings and landscapes covering much of the world, including the UK, Scandinavia, North America, India and Southeast Asia, and lists images under style, place and personality. The library was founded in 1991.

Book Art and Architecture Picture Library
1 Woodcock Lodge
Epping Green

Hertford
SG13 8ND
UK
Tel: +44 (0)1707 875 253
Fax: +44 (0)1707 875 286
sharpd@globalnet.co.uk

Boxing Picture Library
Handles imagery of famous fights, boxers and boxing personalities from around the world. Could be worth contacting if you have imagery of famous boxers in their early days or any special imagery.

Boxing Picture Library
3 Barton Buildings
Bath
BA1 2JR
UK
Tel: +44 (0)1225 334 213
Fax: +44 (0)1225 480 554

Bridgeman Art Library
An image library containing fine-art imagery for publications. The Bridgeman acts as an agency for many private museums and galleries around the world, offers a research service and acts as an agency for contemporary artists. Founded in 1971.

Bridgeman Art Library
17-19 Garway Road
London
W2 4PH
UK
Tel: +44 (0)20 7727 4065
Fax: +44 (0)20 7792 8509
e-mail: info@bridgeman.co.uk
www.bridgeman.co.uk

Britain On View
A photograph library focusing on all aspects of British culture, British tourism, British towns and villages, various attractions and so on.

Britain on View
43 Drury Lane
London

WC2B 5RT
UK
Tel: +44 (0)20 7836 6608
Fax: +44 (0)20 7836 6553
www.britainonview.com

Camera Press Ltd
Library of photographic images including politicians, royalty, entertainers and more. Founded in 1947.

Camera Press Ltd
21 Queen Elizabeth Street
London
SE1 2PD
UK
Tel: +44 (0)20 7378 1300
Fax: +44 (0)20 7278 5126

Crafts Council Picture Library
Comprehensive library containing anything to do with British crafts, from woodwork, jewellery and pottery to anything decorative. The library has an interactive database and images are supplied in digital formats, which is good for digital photographers. Founded in 1973.

Crafts Council Picture Library
44A Pentonville Road
London
N1 9BY
UK
Tel: +44 (0)20 7806 2504
Fax: +44 (0)20 7837 6891
photostore@craftscouncil.org.uk

Environmental Investigation Agency
A specialist library of images of any illegal environmental issues, such as trading in endangered species, environmental pollution and so on. May also accept images of rare animals in their natural environment. Founded in 1984.

Environmental Investigation Agency
69-85 Old Street
London
EC1V 9HX
UK

Tel: +44 (0)20 7490 7040
Fax: +44 (0)20 7490 0436
e-mail: communications@eia-international.org
www.eia-international.org

Greg Evans International Photo Library
General library containing 300,000 images, which accepts photographers' submissions. Founded in 1979.

Greg Evans International Photo Library
6 Station Parade
Sunningdale
Ascot
Berkshire
SL5 OEP
UK
Tel: +44 (0)20 7636 8238
Fax: +44 (0)20 7637 1439
e-mail: greg@gregevans.net
www.gregevans.net

Fortean Picture Library
My personal favourite, a library containing anything of a Fortean nature: UFOs, ghosts, phantom ships, mystery big cats. Also accepts ancient historical sites.

Fortean Picture Library
Henblas
Mwrog Street
Ruthlin
LL15 1LG
Wales
UK
Tel: +44 (0)1824 707 278
Fax: +44 (0)1824 705 324
e-mail: janet.bord@forteanpix.demon.co.uk
www.forteanpix.demon.co.uk

Freelance Focus
A UK and international network of freelance photographers that has a library of over 2 million stock images. Various assignments are carried out on behalf of clients, with a subject list available on request. Founded in 1988.

Freelance Focus

7 King Edward Terrace
Brough
East Yorkshire
HU15 1EE
UK

Snookerimages
Specialists with a 20,000-image library of professional snooker players on and off the table dating back to 1984.

Snookerimages
PO Box 33
Kendal
Cumbria
LA9 4SU
UK
Tel: +44 (0)1539 448 894
Fax: +44 (0)1539 448 294
e-mail: eric@snookerimages.co.uk

The Still Moving Picture Company
Library specialising in Scotland and all things Scottish, with over 250,000 images on its books. Founded in 1991.

The Still Moving Picture Company
67a Logie Green Road
Edinburgh
EH7 4HF
Scotland
UK
Tel: +44 (0)131 557 9697
Fax: +44 (0)131 557 9699
e-mail: stillmovingpictures@compuserve.com
www.stillmovingpictures.com

Stockwave
Library featuring social and political news, industry, tourism, technology and defence, with a British bias.

Tel: +44 (0)1296 747 878
Fax: +44 (0)1296 748 648
e-mail: enquiries@stockwave.com

Tony Stone Images
Major international library that still requires images of travel, people, commerce, history, nature and sport. Does a lot of business online and also sells digital images, so digital photographers have another potential outlet. One of the outlets I use when I need to purchase imagery for publication. Always of high standard.

Tony Stone Images
101 Bayham Street
London
NW1 OAG
UK
Tel:+44 (0)20 7544 3333
Fax: +44 (0)20 7544 3334
www.tonystone.com

This is just a small selection of the picture agencies and libraries out there; more comprehensive listings can be found online or in the *Writers' And Artists' Yearbook*, which has an invaluable amount of information for any aspiring freelance photographer and is a recommended purchase.

Bear in mind when approaching any picture agency that you should always apply in a tentative fashion, first asking whether or not it is accepting any photographic submissions from new photographers. If it is, ask which formats are acceptable and if there are any specific requirements. If there is still interest, a sample of work may be required and the agency will get back to you either with a rejection or an offer of terms. Also, bear in mind that there are photo libraries for virtually every subject you can possibly think of. Even if you have the most obscure collection of high-quality images, there is likely to be an agency or library that may have an interest in your work.

publications

The following two publications have complete directories for this particular section of the photographic industry:

Elfande Ltd
Surrey House
31 Church Street
Leatherhead
Surrey
KT22 8EF
UK

Tel: +44 (0)1372 220 300
Fax: +44 (0)1372 220 340

Elfande publishes *Contact Photographers*, which is more photography-orientated.

Variety Media Publications
6 Bell Yard
London
WC2A 2JR
UK
Tel: +44 (0)20 7520 5233

Variety publishes *The Creative Handbook*.

Photoshop keyboard shortcuts

From the tutorials where you have been learning about digital imaging skills and the industry standard Photoshop software, you will have noticed that, whereas you can go the snail route and select everything from menus, it is normally easier and an awful lot faster to be able to access any functions you require via keyboard shortcuts. This is a useful quick-reference guide which should help you speed up your Photoshop skills. It isn't comprehensive but will provide you with a quick route to the tools and commands you will be using on a regular basis.

Mac users: replace 'Ctrl' with 'Cmd' and 'Alt' with the 'Apple' key.

menus
File

New	Ctrl + N
Open	Ctrl + O
Save	Ctrl + S
Save as	Ctrl + Shift + S
Print	Ctrl + P

Edit

Cut	Ctrl + X
Copy	Ctrl + C
Paste	Ctrl + V
Fill	Shift + Backspace (delete)
Fill > foreground	Alt + Backspace
Fill > background	Ctrl + Backspace
Free transform	Ctrl + T

Image

Adjust > levels	Ctrl + L
Adjust > autolevels	Shift + Ctrl + L

Adjust > curves	Ctrl + M
Adjust > hue saturation	Ctrl + U
Adjust > desaturate	Shift +
Adjust > invert	Ctrl + I

Layer

New > layer	Ctrl + N
New > layer from copy	Ctrl + J
New > layer from cut	Shift + Ctrl + J
Merge down	Ctrl + E

Select

Select all	Ctrl + A
Deselect	Ctrl + D
Inverse	Shift + Ctrl + I
Feather	Ctrl + Alt + D

Filter

Use last filter	Ctrl + F

View

Zoom in	Ctrl + '+'
Zoom out	Ctrl + '-'
Show/hide extras	Ctrl + H
Show/hide guides	Ctrl + '
Show/hide rulers	Ctrl + R

tool selection

Button graphic	Tool Name	Shortcut
B graphic 1	Rectangular marquee	M or Shift + M
B graphic 2	Elliptical marquee	M or Shift + M
B graphic 3	Move	V
B graphic 4	Lasso	L or Shift + L
B graphic 5	Polygonal lasso	L or Shift + L
B graphic 6	Magic wand	W
B graphic 7	Airbrush	J
B graphic 8	Paintbrush	B
B graphic 9	History brush	Y
B graphic 10	Gradient	G or Shift + G
B graphic 11	Paint bucket	G or Shift + G
B graphic 12	Blur	R or Shift + R
B graphic 13	Smudge	R or Shift + R

Button graphic	Tool Name	Shortcut
B graphic 14	Type	T
B graphic 15	Pen	P
B graphic 16	Rectangle	U or Shift + U
B graphic 17	Rounded rectangle	U or Shift + U
B graphic 18	Ellipse	U or Shift + U
B graphic 19	Polygon	U or Shift + U
B graphic 20	Line	U or Shift + U
B graphic 21	Custom shape	U or Shift + U
B graphic 22	Eyedropper	I
B graphic 23	Swap foreground and background colours	X
B graphic 24	Revert to default colours	D

thoughts and musings on the future of photography

f you'd have told a photographer, even 20 years ago, that in a couple of decades' time the traditional camera would be on the way out and the latest high-tech films and photo-imaging techniques would be replaced by zeros and ones, you'd have probably been burned at the stake for heresy. Nonetheless, two decades down the line and where do we find ourselves? Exactly! But how does that bode for the future of photography? What is the ultimate goal of photographic technology? And how will new photographic technologies change the way we relate to our world in this new century?

Well, if the truth be known, nobody knows, but I've been keeping my finger on the pulse for some time now, and there are some exciting technologies that really will change our lives ultimately and for ever – though hopefully not in the way everybody thought virtual reality would a few years ago!

Photography is first and foremost a means of communication; a visual means, but a means all the same. Unlike a page full of text, an image has the ability to motivate, provoke and stimulate many different people in many different ways. Because photography is a subjective art, no two people ever respond to a photograph in quite the same way: a photograph of somebody being tortured will provoke revulsion and horror in most people, but if you were a torturer viewing the same image, your thoughts may wander from revulsion to curiosity – 'He's not doing that very efficiently.' The infinite variations in the way people respond to imagery and the reasons why they respond in certain ways mean that photography, regardless of the technology, will always remain dynamic, interesting and contentious.

Present photographic technology has moved from darkrooms, chemicals and general fiddling (well, to an extent with the fiddling!) to the more clinical, all-encompassing automatic modes, which may sometimes give less scope for artistic integrity but do ensure that instead of photography being the art of

a few, it now has genuinely been bought to the masses. A little time learning basic photographic skills and image-manipulation techniques means everyone can get involved, which in the long run can only be good for the industry and will also, in due course, lead to a greater level of creativity and art than traditional photography ever has done. But where does that leave us with the next generation of photographic technologies? We've sold our souls and gone digital, so where does it end?

As with computers, the technologies that made digital photography possible are constantly being enhanced and within a few months of discoveries in image compression, storage or a further increase in already massive resolutions of digital images, the entire groundbreaking technologies suddenly get superseded by faster, better, more technically proficient ones. The older, but still eminently capable technologies, become cheaper and cheaper and again spread out into the wider community. This is a good thing, but like computers, I wonder if higher resolutions and better storage are really the answer. Very little research has been done by any of the major manufacturers or leading universities. Undoubtedly, these elements and enhancements are what consumers demand, but all the digital age of photography has so far accomplished is to mimic what traditional photography has done for years and make it easier to share and manipulate the images. To me, despite the leaps and bounds of this technology, that doesn't seem like a huge amount of progress.

Photography itself is flawed, since light in a vibrant three-dimensional scene is flattened to a two-dimensional image. Special techniques and the use of movement, perspective and more give a false illusion of depth to imagery. I believe that photography in this format has long been optimised and it's time for the public to demand the next level: 3D photography. This kind of imagery has already been available for some time but, as with all new technologies, it starts off by being very expensive, has limited levels of quality and no proven commercial track record. When you take a picture, you are trying to communicate to the viewer the essence of the moment, not simply a flat representation of what you saw. I'm sure you think the concept is good, but it won't be with us for years. Well, that's the thing actually – we have had this technology available for the past 150 years! Okay, so it has again been in the past few decades that serviceable 3D imagery has been a possibility. Imagery in 3D isn't limited to anaglyph (the old red and blue images with the '50s movie glasses to provide an illusion of three-dimensionality) and stereoscopic cameras can now be purchased easily online. Of course, the amount of research money that has been ploughed into 3D viewing is minuscule compared to that spent on squeezing that very last level of functionality out of traditional 2D photography, but at present even the lower-end digital cameras have such incredible levels of functionality that soon there will be no differentiation

between a £50 camera and one that last year would have cost well in excess of £1,000.

Soon, major corporations and manufacturers will be forced not just to look to the future, but actually start production of these 3D technologies, and after the same filter-down cycle of financial restriction on new technologies, we will have photo albums that literally leap out of the page. Fair enough, present 3D technologies are based on two images with slightly different perspectives being placed side by side and the viewer having to alter their eye focus, but after a few years (okay, more like a few decades probably) the photographic equivalent of hologram images will have entered every home in the country and our ability to communicate our own experience will have taken a further quantum leap in the right direction.

And, of course, 3D is just the start. With nanotechnology coming on in leaps and bounds, how long will it be before the entire concept of viewing imagery with our eyes is long gone? How vivid are your dreams? I'm pretty sure you visit an entirely mind-created fully-immersive 3D environment every day – indeed for a good portion of the third of your life you spend asleep. Soon the ability to hard-wire or beam imagery directly into our creative cortex will be a reality and we will be able to experience a perfect moment exactly the way it was meant to be captured, not the way a photographer *had* to capture it given the limitations of the available technology. After static internal holographic imagery becomes a reality, we will be able to enter different planes of existence: a world of virtual reality where we cannot just experience a static perfect moment, but also other spectrums of life that otherwise we would not be able to consider. Come to think of it, how do we know we aren't doing that already? (Sorry, I went a bit *Matrix* there!)

Don't get me wrong – I love digital photography, I love photography – hell, I love all imagery that is considered, evocative and strong, and I believe there will always be people who will take static 2D imagery, even with that almost freakish chemical-coated analogue jiggery-pokery (sorry to any trads out there, you're OK really!), but everyone will then have the ability to choose the way they want to communicate and not just the way that restricted technological practices dictate. I just hope I'll get to see this photographic liberation in my lifetime. Just remember, we always think we are at the absolute pinnacle of evolution at any individual moment – and by definition we are – but in 50 years' time whoever is alive *then* will be at the pinnacle of evolution and we will just be relics of a long-and best-forgotten age.

So, to everyone out there: keep happy and keep snapping.

glossary

This is an extensive glossary of photographic terms. Some are related only to traditional photography, but are still useful for the digital-photography enthusiast. These have been marked 'general'.

aberrations

Lens defects likely to mar the image produced. Common names for certain aberrations are 'astigmatism', 'coma', 'distortion' and 'spherical aberration'. Imagine a lens has a major scratch that will appear in every image you make: this is an aberration. Fortunately, the advent of digital-editing packages means that aberrations in a lens no longer need ruin an image.

additive synthesis

This is the method that creates images by mixing the primary colours of light: red, green and blue.

aerial perspective

The impression of depth in landscape photography in which further planes appear to be softer than closer ones.

airbrushing

The analogue precursor to digital image-editing software, where an artist manually sprays fine inks on to film or on to a finished photograph.

angle of incidence

The angle formed by an incoming ray of light and the axis of the lens at the point the ray of light touches the lens.

angle of reflection

This is identical to the angle of incidence, but on the opposite side of the axis, where a ray of light has struck a lens.

angle of view

The widest angle at which light rays entering the camera lens will give a full

image without blanking out any sections.

aperture

This is the opening in a lens that controls the amount of light that passes through the lens and on to the camera's CCD sensor. The aperture can be modified by camera settings dependent on the make and model.

aperture priority (general)

This is a system whereby the camera allows the photographer to choose the aperture while automatically selecting a relevant shutter speed.

artificial light

Any illumination other than daylight.

ASA rating (general)

ASA is the American Standards Association and is a rating used in traditional photography to indicate how sensitive the photographic film is to light.

astigmatism

A lens aberration which makes it impossible to create images that are sharp along both horizontals and verticals.

automatic cameras (general)

A camera in which the exposure is partly or wholly controlled by the internal features of the camera. In completely automatic cameras, sensors adjust exposure without input from a photographer, which can be good for amateur photographers, but allows for limited control and creation of artistic effects within your photography.

available-light photography

Taking pictures without the addition of any supplementary light: images taken at dusk or early morning, for example.

backlighting

Any lighting which comes from behind the subject of a photograph.

barn doors

An attachment that fits on to the front of a light to allow the photographer to specifically control the way the light spreads.

bellows

Bellows units are light-proof folding tubes that can be fitted to the body of the camera to enable extra close-up photos to be taken. These units can be found

for certain camera brands, but not for many lower-specification cameras. Check with your digital camera manufacturer to see if a compatible unit is available.

binary

A data language which can represent anything that is constructed entirely of zeros and ones. It is the simplest means of information communication.

blower brush

Part of a lens-cleaning kit. This brush combines a soft brush and an air-blowing bulb that enables you to clean your lens with minimum surface damage.

boom light

A light attached to a long pole which allows subjects some distance from the camera to be illuminated in poor lighting conditions where there is no static artificial light available.

bounced flash

A flash which illuminates an object indirectly by reflecting off a wall, mirror, fish tank, window, etc.

bracketing

This is where a number of shots are taken of the same image with slightly different brightness levels, so you can pick the best picture and discard the rest.

brightness range

The range of luminance from the lightest to the darkest area of a picture. Scenes with a high-brightness range tend to have good levels of contrast whereas ones that have a low range tend to be flat.

BSI (general)

A now-obsolete standard for rating film speeds in analogue photography.

camera shake

Any time you take a picture by hand, the image will be shaking – even if the result is so small you can't see it. It is more noticeable in digital cameras that have slower shutter speeds. It can be avoided by using a tripod or monopod.

channels

Digital images are made up of three channels: red, green and blue, which are the primary colours of light. Each channel contains a numeric value from 0 to 255, giving 256 overall brightness levels that range from black to white. When these greyscale values are combined, a coloured image is formed.

CCD

Abbreviation of Charged Coupled Device. This is a type of image censor that has become the dominant kind used in digital cameras. Light hits the sensor and is converted into a stream of binary information, based on the light's hue (colour), saturation (amount of colour) and lightness (how bright or dark the colour is).

cloning

A method of copying complex data and pasting it with a tool like a rubber stamp over another part of an image to remove blemishes or even entire items from a digital image.

close-up lens (general)

An analogue lens which allows for extremely close-up photography and produces results similar to macro-functions in modern digital cameras.

coated lens

A type of lens that has been specially coated to reduce the possibility of lens flare. Rare for digital cameras.

colour correction

Any method used to change the balance of colours within an image to give a more pleasurable final image.

colour mapping

Taking one colour and mapping on to another, along with changing all similar tones to create the illusion of the mapped colour being the initial colour within an image.

colour temperature

This is a measurement of light (in kelvins) which determines the colour quality of light.

complementary colours

These are the secondary colours of light: yellow, cyan and magenta. They are at opposite sides of the colour wheel to their respective primary colours of light.

contrast

The relationship between different tonal values within an image: they can be different brightness tonal values or different colours. Contrast between different tones is what actually displays detail on a photograph.

converging verticals

The distortion caused in an image when a camera is pointed, for example, directly upwards at a skyscraper from ground level. This distortion can be corrected with a perspective-control lens, although these are generally only available for high-end digital cameras that allow you to swap lenses. Extensions for fixed lenses are very rare.

convertible lens

A type of lens made up of compound modules that can be separated, giving a single lens significantly more functionality.

cropping

Trimming a digital image to dimensions smaller than those at which the original image was taken.

cyan

The complementary colour of red; a combination of blue and green light.

delayed action

A digital-camera function that allows a timed period to elapse before the camera will take an image. With a tripod-mounted camera this allows you to point to a focused area and then get in front of the camera, so you can also be in the photo.

depth of field

Depth of field is the distance between the nearest and furthest point from the camera within which the subject will remain clearly in focus.

depth-of-field tables

Written tables which set out acceptable depth-of-field ranges for given focus distances and aperture sizes.

development (general)

The yawn-some analogue photographic practice of having to take a film into a darkroom, coat the film with chemicals and expose it to light, etc, etc, yawn, yawn, yawn. Digital photography needs no such mundane practices, with development happening immediately. The point of development in a digital camera is the point at which binary information is converted to a recognisable image format.

diaphragm

This is a name for the adjustable aperture of a lens.

differential focusing

Setting the camera's aperture to give a clear subject but a blurred, out-of-focus background.

diffuser

A material placed in front of a light or flash that softens the quality of the light, reducing harsh contours within an image. A sheet of thin white tissue paper is suitable for this purpose.

diffusion

The method of diffusing light to make light fall more softly on a subject, removing areas of harsh contrast and giving a softer overall image.

DIN rating (general)

Deutsche Industrie Normen is another film-speed scale sometimes preferred to the ASA rating. Now generally superseded by ISO numbering.

dissolve

Fading between two images in an image-editing package either by altering a layers opacity or by deleting areas of an image over a gradient.

duplication

Making copies of an image.

enlargement

Blowing up a digital image to a resolution higher than that at which it was initially taken. Although it is not possible to increase detail in digital images by interpolating, it is possible to increase the overall resolution to some extent before human eye is able to detect a loss of quality in the image.

exposure

This is the volume of light that reaches the CCD sensor in your digital camera to create a photograph. A photo is called an 'exposure' as it has been created from a sensor's 'exposure' to light.

F-number (general)

A scale of numbers used in analogue photography to refer to the size of the aperture used. Sometimes F-numbers are referred to as 'F-stops'.

fill light

A light that is extra to the main light source, able to reduce contrast and remove unwanted shadows in a scene.

filter

1 A physical item which modifies light passing through it to change a photograph's exposure.
2 A software algorithm in an image-editing package designed to add a special effect to your digital images.
3 A coloured piece of glass, plastic or a 'gel' (gelatine sheet), which modifies the colour of light passing through it.

fish-eye lens

An extreme wide-angle lens and also a software filter that gives the illusion of an image having been taken with a camera that has a fish-eye lens. Fish-eye lenses can view as wide as 180 degrees

fixed-focus camera

A type of camera that has no means of changing the distance of the lens from the CCD. This kind of camera is the cheapest and least useful. Fixed focus is rare in digital cameras, although it can be found in mobile phone cameras and digital cameras costing as little as £30 ($50).

(lens) flare

Light scattered by reflections within a lens.

flash

An electronic ignition of neon-gas vapour that creates an intense burst of light for illuminating subjects in poor lighting conditions, generally indoors. Flash can create red-eye, which is the natural colour of the retina in the back of the eye when intense light is beamed on to it.

focal length

The distance between the back of the camera lens and the focal plane, when the lens is focused on infinity (or nothing).

focal plane

The imaginary plane at right angles to the lens axis at which a sharp image is formed when the exposure is made.

focal point

The point on the focal plane where the optical axis intersects at right angles.

focus

The point at which light rays from the lens converge on the CCD sensor to give a clear, sharp image.

gel(atine)

The name given to a thin, transparent coloured sheet of plastic that can either be held directly in front of a lens to tint an overall image, or over a light to shine coloured light on to a subject. More commonly used in film, gels can add interesting moods to photographs, but it is easier to add a gel-style effect in an image post fact than it is to use one directly in a shot.

glossy paper

Printer paper that gives a glossy finish, like the pictures you could have developed if you owned a standard camera.

gradient

A gradient is a gradual transition from one colour or area of transparency to another. Gradients can be linear, radial, angled or diamond.

grain

Digital-camera grain is largely digital fuzz created by the software compressor which stored the digital image. Traditional film grain comes from tiny clumps of black silver formed in an emulsion after exposure and development.

high key

Photographic imagery that has most of the tones taken from the lighter end of the spectrum.

highlights

The lightest parts of an image; the opposite to shadows.

HLS

Another way of looking at the colour value of a pixel. Instead of being defined in terms of red, green and blue channel strengths, it looks at hue, lightness and saturation, with hue being the type of colour (red, orange, beige, etc), saturation measuring how much of the colour is present in the pixel and lightness representing how bright the saturated colour in the pixel is. Sometimes also known as HSB (hue, saturation, brightness).

hot shoe (general)

A slot for taking a flash attachment. Not normally used for commercial digital cameras, they are found on high-end cameras where professionals require extra power that couldn't be obtained from a built-in model.

hyper-focal distance

The closest point to a camera lens that will give an acceptable level of

sharpness when the lens is focused to infinity. Focusing on this specific distance increases the perceived depth of field.

infinity

A camera-to-subject distance beyond which focusing differences are so slight as to be practically non-existent. In general terms, any distance over 1km.

invert

An image-editing package command which will convert all selected areas' colours to their opposite; thus whites become blacks and all colours in between are altered accordingly.

ISO (general)

International Standards Organisation: another standard used to indicate the speed of film in analogue photography.

joule

An output measurement for electronic flashes, equivalent to 1W per second.

JPEG

Joint Photographic Experts Group is the name of an image-compression standard widely used in digital cameras.

kelvin

The unit of measurement for colour temperature. Daylight, for example, has a heat rating of 5,400 degrees kelvin.

lens

A convex, pure sheet of glass used to focus light in a scene into a specific region on a CCD image sensor. This then records the light into a recognisable format. There are numerous types of lenses available, all with different abilities to get the most out of varied situations.

lens cap

A protective covering for a camera lens. Many digital cameras do not have lens caps and automatically retract their lenses for protection.

lumen

A unit of measurement for light intensity. The higher the level of lumens, the stronger and more harsh the light.

macro lens

A lens specifically designed for extreme close-up photography.

macro photography (general)

The photographic genre of taking close-up images, which when printed will be larger than their natural size.

magenta

A combination of blue and red light, the complementary colour of green.

marquee

A selection made in image-editing software that allows the artist to affect only the area within the perimeter of the marquee. Also known as a mask.

mask

Another name for a marquee.

maximum aperture

The largest possible size for your camera's aperture to open up to. Lenses with large apertures are known as fast lenses.

modelling

A stylistic technique using light and shade to emphasise a scene's irregularities.

monochromatic

The technical term for black-and-white images.

monopod

A single-legged adjustable camera stand.

montage

A complete picture made up of a collection of other pictures.

motion blur

The blurring in an image that occurs when an exposure is slower than an item moving within the stream, so a light trail is captured on the CCD.

negative (general)

Traditional analogue cameras used to record an image as a negative. Light was then shone through and on to coated chemical paper which reversed the negative, creating the perfect photograph.

Newton's rings

A kind of lens-flare effect whereby rainbow-coloured circles appear on an exposure. It is hard to create this effect intentionally.

opacity

Opacity is the opposite of transparency, yet means the same thing. A 50% opaque image is 50% transparent. A 100% opaque image is solid; an image that is 0% opaque is fully transparent. Alpha channels in certain digital-imagery formats allow software to record opacity information as well as the standard three channels of colour.

pan head

An attachment for tripods that allows a mounted camera to be panned smoothly.

panning

The camera technique of swinging the camera to follow a moving subject so that the subject stands out well against a blurred background.

parallax

The difference between what the camera lens and the camera viewfinder see. This difference is removed in cameras with SLR functionality.

perspective

The impression of depth and distance created by the relative size of objects at different positions and by the apparent conversion of parallel lines.

perspective control lens (PC)

A type of lens which allows adjustments to be made at right angles to its axis. This kind of lens allows the photographer to alter the field of view without moving the camera. It is also known as a shift lens.

photoflood

A lamp which has a similar filament to those used in powerful floodlights.

photomicrography (general)

The art of taking photographs through a microscope with the camera directly attached to its eyepiece. I haven't seen a digital camera with such an attachment yet, but here's hoping for some development soon!

pixels

Comes from the words 'picture' and 'element'. A pixel is a small square 'dot' that contains hue, saturation and luminance values that are refreshed thousands of times a second. Digital images are maps of pixels, with each pixel having a set numeric value to create the overall illusion of a picture.

plug-ins

Third-party code added to image-editing software to increase its overall functionality. There are many filters which are third-party plug-ins.

polarised light

Light which has been reflected from a plane such as a mirror, fish tank or window, which adds unnatural illumination to a scene.

polarising filter

A colourless filter which absorbs polarised light, thus allowing glare to be removed from shots.

posterisation

An artistic technique whereby colour values within a photograph are restricted to a finite integer, rather than a multitude of smooth graduations.

pre-focusing

Focusing not on a picture's actual subject but on a point the subject is expected to pass through and then taking the picture when the subject crosses this point.

print

A printed digital photo. Also refers to a traditionally produced photograph.

reciprocity

The relationship between lens aperture and shutter speed, so designed that the step between adjacent settings on either scale always increases or decreases the exposure by the same factor.

red-eye

The effect sometimes produced by flash bulbs in dark pictures whereby a subject's eyes turn red because of the reflected colour of light from the retina.

reflector

Any item that can reflect and direct natural (or artificial) light existing in a scene back on to another part of the scene to improve overall illumination.

refractive index

The numeric value of a transparent subject's ability to bend light when light passes through it. Think of a glass of water and how light is distorted when you look through it; that is refraction and a specific numeric value is its index.

retouching

The digital removal of unwanted marks on images to modify and improve them post-picture.

RGB

Abbreviation indicating the channels of light (red, green and blue) and the most common way of recognising the individual colours of pixels. Another variation is HLS.

sharpen

A brush-based image-editing tool that can paint over an image to increase the contrast underneath. Also, increasing focus.

shift lens

The alternative name for a perspective control lens

shutter

The part of a camera that controls the time light is allowed to pass through the aperture and on to the lens.

silhouette

A photographic technique whereby only a subject's outline is visible in an image. To achieve this technique, a subject should be dark and be shot against a backlit scene.

soft focus

An effect that degrades the amount of contrast around elements of an image. In digital photography this can be done at a software level as the on-board computer decreases contrasting colours and brightness levels to mellow out a picture.

spectrum

White light is a combination of all the colours of the spectrum. The spectrum can be viewed by passing white light through a prism, which splits the light into its composite components.

spherical aberration

A marked lack of sharpness in an image created by light passing through the lens in a way that forms a focus in a position not picked up by the CCD.

standard lens

A camera lens which gives an angle of view and a scale approximate to that of human vision.

stop

Another name for an F-number.

synchronisation

Setting up a digital camera's flash and shutter to ensure that an exposure is made at the precise moment that light from the flash is reflected back at the lens.

telephoto lens

An add-on lens which can increase the focal length of any lens with which it is combined.

tonal range

The difference between the density of the brightest and darkest parts of an image. Also used to describe the reflective powers of a subject.

toning

The modification of an image's tonal values so it is desaturated but with a pervading single-coloured hue. This can be sepia, blue or selenium.

tripod

A three-legged adjustable camera stand.

tungsten lighting

Artificial lighting like that given off by ordinary light bulbs.

ultra-violet filter

A filter which reduces the amount of ultraviolet radiation in a scene. This is particularly useful when shooting at high altitudes, such as up mountains or from aircraft, where there is a lot more of this radiation and it is likely to distort colours in an image.

under-exposure

When there is insufficient light available to create a strong image. Photographs taken at dusk or in darkened rooms are likely to under-expose.

vignette

A printing technique that fades the edges and sides of images to a darker background colour. This technique was popular in traditional analogue photography years ago, but can now be copied easily with image-editing packages.

vindaloo

Just checking you were paying attention! Nothing to do with digital photography whatsoever.

wide-angle lens

Any lens that has a wider angle of view than a standard lens.

zoom

To blow up a region of an image in an image-editing package so that it can be worked on in greater detail.

zoom lens

A lens with a continuously variable focal length. Many zoom lenses incorporate the facility for close-up photography.

notes

the complete guide to **DIGITAL PHOTOGRAPHY**